mosaic
basics

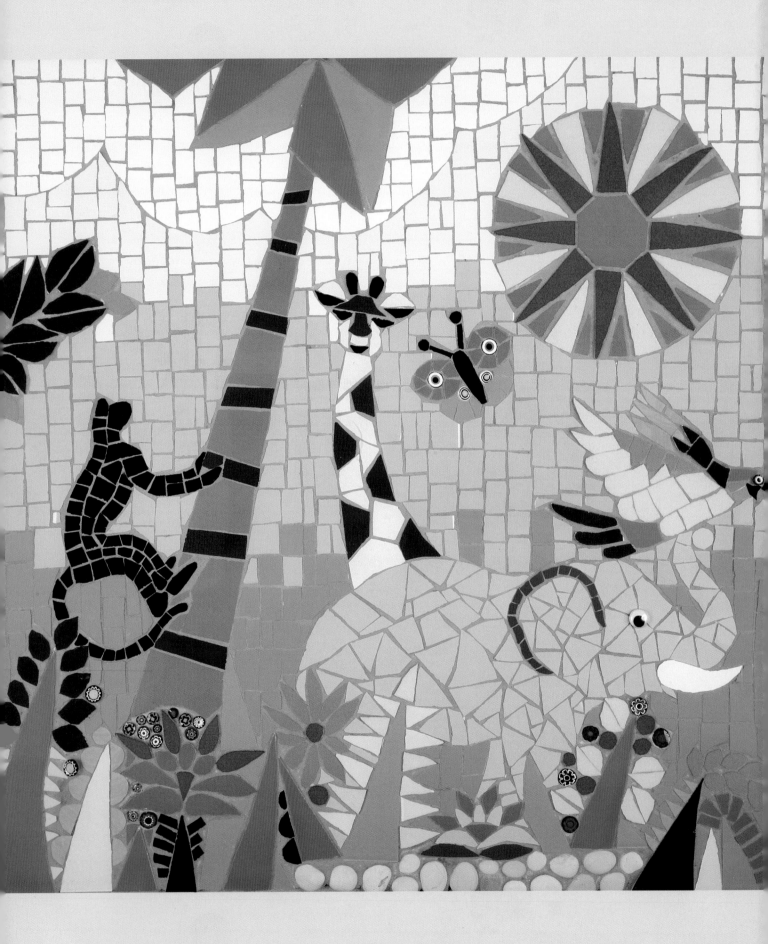

mosaic
basics

Everything you need to
know to start making
beautiful mosaics

Teresa Mills

BARRON'S

First edition for North America published in 2007 by
Barron's Educational Series, Inc.

All inquiries should be addressed to:
Barron's Educational Series, Inc.
250 Wireless Boulevard
Hauppauge, NY 11788
www.barronseduc.com

ISBN-10: 0-7641-5961-5
ISBN-13: 978-0-7641-5961-9
Library of Congress Control Number
2005936252

QUAR.MOBA

Conceived, designed, and produced by
Quarto Inc.
The Old Brewery
6 Blundell Street
London
N7 9BH

Project Editor Donna Gregory
Senior Art Editor Penny Cobb
Designer Penny Dawes
Text Editor Diana Chambers
Photographer Martin Norris
Illustrator Kuo Kang Chen
Indexer Dorothy Frame

Art Director Moira Clinch
Publisher Paul Carslake

Manufactured by PICA Digital, Singapore
Printed by Star Standard Industries (PTE) Ltd, Singapore

Printed in Singapore
987654321

CONTENTS

INTRODUCTION

This book is aimed at those who are just discovering mosaics for the first time, who have perhaps recently seen a mosaic design or picture, and thought that they would like to try to make their own mosaic.

On the following pages you will find step-by-step guidance on the different techniques that are needed to create a mosaic: from preparing a design, cutting and laying tiles, through to grouting and mounting your work. The projects that follow the basic technique section will enable you develop and master those skills in a practical way, while, hopefully, creating an end result that will delight you.

This book is about more than just the correct use of materials and tools—it will give you an insight into how the uniquely intense colors and qualities of glass and ceramic tiles can be combined to produce exciting results. In working through this book I hope you discover for yourself what is possible, how you can vary and adapt ideas, and become confident in exploring and experimenting with the medium.

The projects therefore should be approached not as "paint-by-numbers" exercises to be slavishly worked through but as a framework within which you can explore and experiment—with different colors, tiles, cuts, and grouts. I've also included some examples of mixing and matching other materials—such as millefiori tiles, shells, and old crockery—and other possible embellishments such as creating your own hand-painted patterns or pictorial details.

There are mosaic methods and techniques to understand and master that are not covered in this book. However, as you go forward, I hope that some of what you learn on the following pages will stay with you and be the foundation on which you build your skills in—and love for—mosaic art.

HOW TO USE THIS BOOK

Setting up your workspace and the materials and tools you need to create mosaics are all described on pages 10–19. The core techniques of preparing your baseboard, transferring, and scaling your design to the correct size, cutting and gluing tiles, grouting, and mounting the finished pieces are explained on pages 20–39. The individual projects that illustrate specific techniques, or require a combination of these, are included on pages 42–123.

Clear step-by-step photographs show exactly how to master all the basic techniques you will need.

TECHNIQUES

Useful hints and tips to help you achieve a professional finish.

Professional examples of the applied technique.

Easily scalable designs
A scalable drawing of each design is shown within a grid to make enlarging the design to the baseboard easier.

PROJECTS

Tiles The colors of tiles recommended for each project are illustrated.

List of tools All of the tools you will need to complete the piece are listed.

Detail Illustrations suggest tips and shortcuts that will develop your mosaic expertise.

Links are included to other relevant techniques and projects.

Step-by-step instructions with clear, close-up photographs, help you understand each stage of the process of creating the mosaic.

Finished project A detailed picture of the finished project provides guidance as you work.

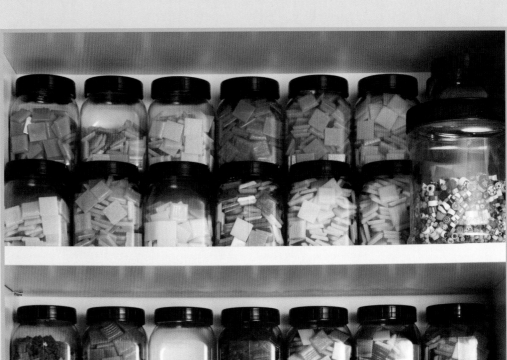

GETTING STARTED

This section will give you a general introduction to all the things you will need to know before you attempt your first mosaic project. Consider it a "starter pack" as a mosaicist! The next 30 pages will take you through setting up your workspace and tell you about the essential materials and tools you will need to acquire. We then show you the basic techniques that apply to almost any mosaic project you undertake: how to scale up your design and transfer it onto the baseboard, how to cut and space tiles correctly, the best way to glue tiles down, and how to grout the finished piece.

It might seem like a lot to learn all at once, but if you approach things patiently and give yourself time to try out each of these different basic techniques, you will quickly be in a position to undertake your first mosaic project.

THE MOSAIC WORKSPACE

As with any craft, it is important to work in the correct environment. It is ideal to have a workshop in your home dedicated to mosaic-making. If this is not possible, you can set up a temporary workspace, cleaning up at the end of each day or after you have completed a project. Whether your work area is permanent or not, there are certain basic requirements, which are explained here.

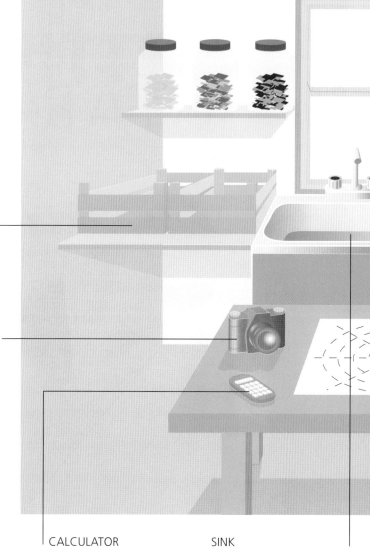

STORAGE UNITS FOR MOSAIC
Once you have built up a reasonable quantity of supplies, you may need to think of creative ways to store them. A cheap and effective way is to store material in fruit boxes. These can be stacked on one another, so they are economical with space. Remember to attach samples of the tiles to the outside, so you can see at a glance which box you need.

CAMERA
This is required to keep a portfolio of finished pieces. It is also useful to keep a record of color experiments and works in progress.

CALCULATOR
This is essential for working out areas and for pricing work.

SINK
It is not essential to have a water supply in the room, but it certainly is useful to have one close at hand, because many mosaic-making processes require water.

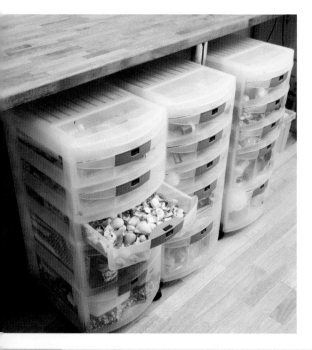

◀ These plastic storage "towers" are another good way of organizing your materials. Here the shallower drawers are used to store shells, which if placed in deeper containers are likely to get crushed. These units are on wheels, which makes cleaning up easier—as does the wooden floor. If you have carpeted floors, protect them with a large decorator's dropcloth while you are working.

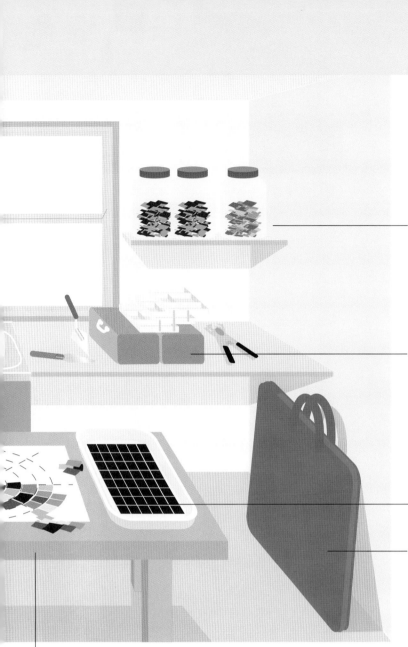

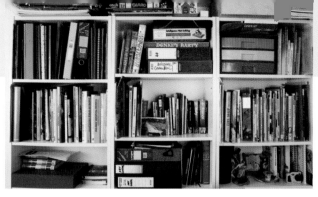

SHELVING
Shelving is an accessible way of storing mosaic materials, because you can see your supplies easily. The colors of the materials themselves can often be inspiring.

▲ File boxes and folders are an ideal way to store cuttings, postcards, and other "source materials" that you come across. You should be a hoarder, not just of materials, but also of designs and ideas.

TOOLBOX
Always put your tools in the toolbox and then you will know where they are when you next need them. Keep them out of reach of children. Remember that some tools are expensive and therefore valuable, so they should be kept in a secure place.

SOAKING TRAYS
You do not necessarily need special trays for soaking tiles off the paper sheets of factory-produced mosaic, but it is easier if the individual sheets are laid flat. It you put too many sheets into a tray together, the water cannot penetrate the paper and the glue does not release, so only soak a few sheets at a time. It is more time-consuming to put sheets of different colors in a tray together, because you will need to separate the colors afterwards. Do not stack wet tiles on top of one another, because they often have residual amounts of glue left on their face from the paper and will stick together again as they dry.

PORTFOLIO
Keeping a portfolio of photographs of your work is a useful discipline. Try to keep a record right from the start. Even if you feel embarrassed about your early pieces, it is encouraging to keep a record of your progress. A portfolio is also useful if you want to show people the kinds of work you can do for commissions.

A LARGE TABLE IN A WELL-LIT LOCATION
Mosaic-making must take place somewhere really well-lit, ideally with natural light. You need to be sure your work can stand up to close scrutiny, and that any color decisions you make are based on an accurate impression.

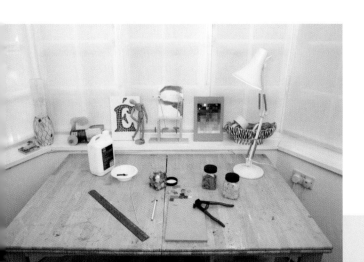

◄ A solid table by a window is the ideal work surface, with lots of space to keep tiles, tools, and glue close at hand. If you care about the surface, make sure to protect it with a cloth or board otherwise it will quickly get scratched and covered with glue.

▶

ORGANIZING THE WORKSPACE

However much or little space you have available in which to do your mosaic work, the principles are the same. You need a strong work surface on which to cut your tiles, with a minimum of clutter (under which the hundreds of wasted pieces you produce can hide). You need good light—ideally daylight—but also a good work light such as an angle-poise lamp. You need a comfortable, upright chair. If you can, make the area as bright and inspirational as possible, decorating it with pictures and cuttings that provide you with ideas. The mosaic workspace should be somewhere both comfortable and stimulating.

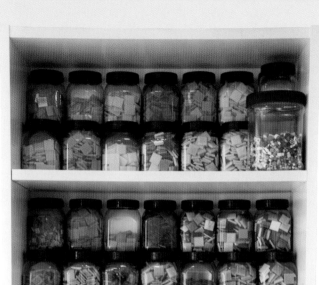

TIP:

If you are cramped for space and cannot dedicate an area to your mosaic work, then the next best thing is to use the biggest tray you can find. On it you can keep your work in progress, the tiles you most use, your tile nippers, and glue. Store it under a bed or on top of a cabinet—it becomes an instant studio whenever you have a spare moment to devote to your craft.

► Collect clear jars or cartons—or buy them from a hardware store—to store your tiles in. Grading them into separate colors makes it much easier and quicker to plan and tile your piece. Any leftovers or miscellaneous bits of assorted tiles can be kept in a separate container.

HEALTH AND SAFETY

If you are going to work regularly with mosaic materials, then you need to be aware of, and follow, the correct health and safety procedures.

The raw material of mosaic is glass—either in the form of solid vitreous tiles or as the glazed surface of ceramic household tiles. You should never underestimate the ability of the edge of a cut—or even uncut—tile to inflict a nasty wound. Always keep your work area clear, sweeping up with a brush and pan—never with your hands. (And always keep some adhesive bandages handy to deal quickly with the inevitable nicks and cuts that you will acquire!)

Quarantine your work area so that tile offcuts and waste are not spread through your home, creating a hazard for children, pets, and other adults. Wear a heavy-duty apron to protect your body and clothes—and take this off at the end of a work session. Similarly, wear shoes that you only wear in the mosaic work area to avoid treading shards of tile into the rest of your living space.

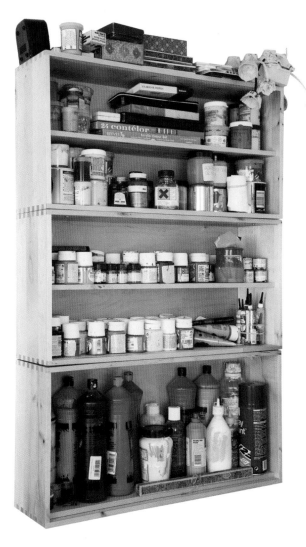

▼ Make sure you also provide storage for pens, brushes, and all the other odds and ends that would otherwise clutter up your work surface.

◀ A place for everything—this shelf stores drawing materials, ceramic paints with which to embellish household tiles, and different acrylic paints with which to color grouts.

Eyes are particularly vulnerable, so always wear eye protection when cutting glass and other materials that are prone to shatter. Opticians can supply you with lightweight safety glasses that will protect your eyes but not hinder your ability to accurately see what you are doing.

Eyes should also be protected from strain by working in well-lit conditions with a good source of daylight, if possible, as well as effective supplemental lighting for when lighting conditions are poor.

Protect your back by making sure that the height of your work surface and the chair or stool you use are set up correctly in relation to each other, so that you are not stooping or hunched while working.

Grouts and other chemicals should be treated with particular respect. Cement-based or exterior grouts contain lime, which is an irritant. If mixing these up from powder, do so outside, wearing a facemask to avoid inhalation of any grout dust. Wear strong rubber gloves when applying these grouts to protect your hands from their corrosive properties.

Lastly, always follow the manufacturer's instructions and read the relevant health and safety information for any product you use—whether a paint, glue, or grout.

TILES

TIPS:

START SMALL

To begin with, practice with cheaper household tiles before moving on to more satisfying, but more expensive, specialty tiles.

MIX AND MATCH

Experiment with mixing and matching different colors, textures, and types of tiles to achieve different effects.

When choosing the materials to use to complete a mosaic project, always begin by taking into account the location of the piece. Most of the projects in this book are pictures intended for display inside and can be created using vitreous glass tiles or ordinary household tiles. Other materials can be combined into your designs, including pieces of broken crockery, pebbles, shells, and pieces of mirror.

VITREOUS TILES

Vitreous tiles are available from craft shops or specialty mosaic suppliers and come in an exciting variety of colors and finishes. Common sizes are ¾-in. (20-mm) square and ⅜-in. (10-mm) square. They can be obtained loose in mixed bags or boxes, or, sometimes, are attached to a mesh or other backing sheet. (This sheet is intended to hold the individual tiles in place so that they can be applied more easily and quickly when they are being used for domestic tiling applications. If you obtain tiles like this, you need to remove the backing sheet by soaking it in warm water and pulling the individual tiles off.)

Vitreous tiles are suitable for use inside or outside—provided you use the correct grout—but they are not recommended for floors since they are very slippery when wet and are liable to chip if something hard is dropped on them.

Tiles can be bought loose from craft shops, but this can be very expensive. A better alternative is to buy them wholesale—you don't have to buy huge quantities. The tiles come on backing sheets from which they can be released by soaking in water.

Vitreous tiles are easy to cut with specialty tile nippers. The tile has two sides. The top—the side you will see—is smooth; the underside is textured to help the adhesive grip the tile.

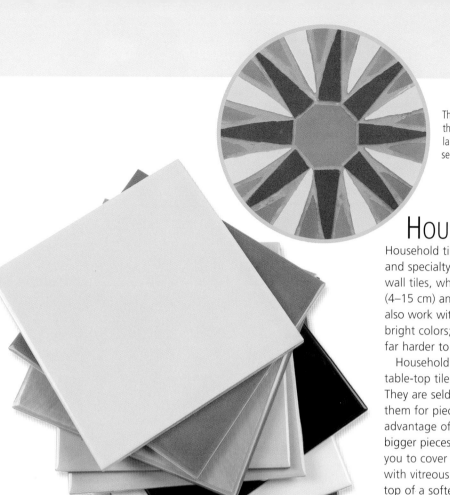

The benefit of using ceramic tiles is that you can cut and work with larger pieces to emphasize some sections of the design.

HOUSEHOLD TILES

Household tiles are readily available from hardware stores and specialty tile shops. Normally, it is best to work with wall tiles, which come in a range of sizes, from 1½ to 6 in. (4–15 cm) and are available in a variety of colors. You can also work with floor tiles, although these rarely come in bright colors; their strength and thickness also make them far harder to cut and work with.

Household tiles can be cut with nippers, split with table-top tile cutters, or even just smashed with a hammer. They are seldom frost-proof, so it is not advisable to use them for pieces that will be kept outside. The chief advantage of this type of tile is that you can work with bigger pieces, giving variety to your design, and enabling you to cover a larger area more quickly than you could with vitreous tiles. Also, they are made of a hard glaze on top of a softer clay-based material which can be cut and nibbled more easily than solid vitreous material.

NATURAL MATERIALS

Alternatively, there are specialty shell shops or craft suppliers who sell a variety of shells and small stones. When using natural materials like these, you normally embed them in a thick layer of a cement-based grout (for example, Project 12, Shell Flower Trough, on pages 88–91). You can't grout shells and pebbles in a conventional way because their surface will be porous, making excess grout difficult to remove and spoiling the finished effect.

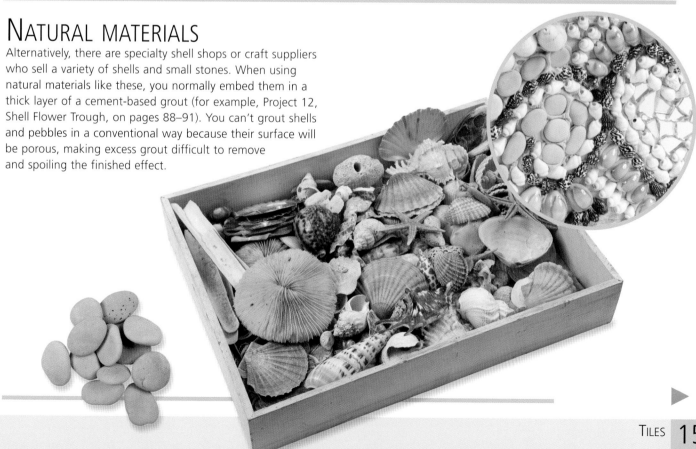

Millefiori tiles tempt you to be extravagant. Here, they have been used on their own rather than mixing them with other materials to add detail or highlights.

MILLEFIORI TILES

Millefiori tiles are little gems of colored glass from Murano in Italy which can be obtained from specialty mosaic suppliers. Although expensive, once you start using them, you will fall in love with their intense color and the interest they bring to a project.

Diamanté can add exuberance and a three-dimensional quality to your design.

DECORATIVE STONES

Diamanté or rhinestones can be added to a piece after it has been grouted and finished to provide additional decoration. They can be stuck on with white glue, but since these types of adornment are easily damaged, the finished project needs to be handled very carefully.

MIRRORED GLASS

Mirrored glass is another eye-catching material you can include in your designs. You can buy mosaic-sized "tiles" of mirror glass which are easier to work with. Alternatively, you can use a glass cutter to create your own tile pieces from larger sheets. Be warned, however, that glass cutting is a skill that can be difficult to master and the results may be unpredictable. Always wear goggles and gloves when cutting glass of any sort as it can produce nasty splinters. Never place cut glass on the edge of a piece that will be handled. Mirror glass should be stuck down with a specialty mirror adhesive, as other glues will attack and, over time, corrode the thin layer of silver that creates the mirror.

Here, patterned fragments from an old plate have provided sufficient materials to create an interesting border detail within the picture.

RECYCLED CROCKERY

A cheap and effective way of making mosaics is to use old crockery that can easily be bought from thrift shops or at rummage sales. A favorite plate or cup that is chipped or broken can also be recycled. Details from a pattern can lend originality and character to a project.

Here, pieces of a decorative tile have been used to provide a patterned infill to sections of a frame.

DECORATIVE WALL TILES

Decorative wall tiles are also another source of mosaic material. You can select a detail and use it for an entirely different effect within your design from what the manufacturer may have originally intended.

TOOLS FOR MOSAICS

There are a number of tools that you should buy before starting any mosaic project. Some of these—such as tile nippers—are obviously essential; others listed here help make the process easier and more enjoyable.

Tile scorer: obtainable from hardware/ DIY stores, use with a steel rule to score the surface of household ceramic tiles, then use tile snappers (right) to break the tile along the line.

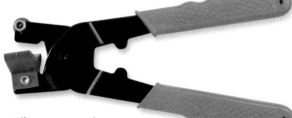

Tile snappers: place a scored tile into the jaws of the tile snapper and squeeze slowly to cleanly break the tile in two. (These tile snappers have a cutting wheel that works like the tile scorer (left), although you may find this a more cumbersome tool to use for this purpose.)

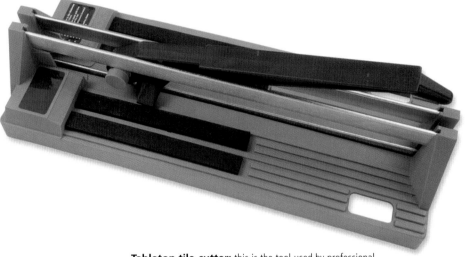

Tabletop tile cutter: this is the tool used by professional household tilers—use it only for ceramic tiles (not for vitreous tiles). More expensive than other hand tools, but invaluable when it comes to cutting large pieces of tiles or producing tile strips. The lever of the cutter scores the tile with one movement, then splits it when more pressure is applied.

Tile nippers: the tool you will use pretty much all of the time, and which is suitable for cutting most types of tile. The correct way to use nippers is to cut in from the side of the tile, using only part of the width of the blade, then squeeze firmly—don't snatch at the tile—to split excess material away. Keep the cutting edges clean, wiping off the glue and tile fragments that inevitably build up.

ESSENTIAL TOOLS:
- Pencil
- Pen
- Ruler
- Spatula
- Tile nippers
- Tile sponge

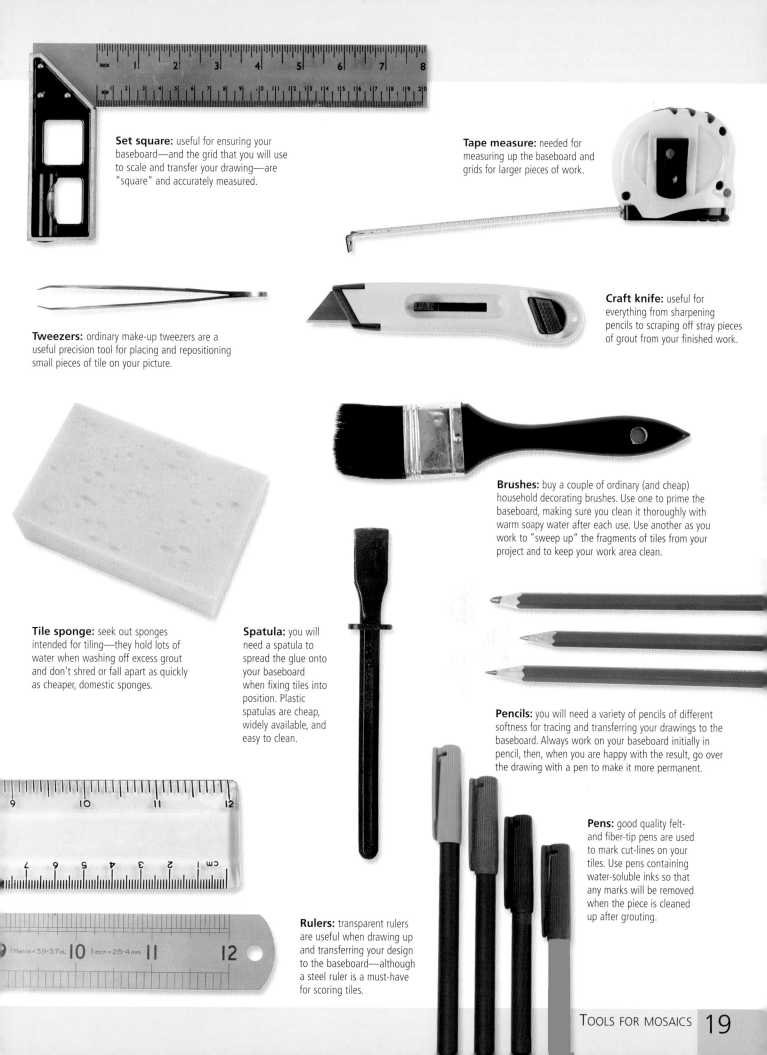

Set square: useful for ensuring your baseboard—and the grid that you will use to scale and transfer your drawing—are "square" and accurately measured.

Tape measure: needed for measuring up the baseboard and grids for larger pieces of work.

Tweezers: ordinary make-up tweezers are a useful precision tool for placing and repositioning small pieces of tile on your picture.

Craft knife: useful for everything from sharpening pencils to scraping off stray pieces of grout from your finished work.

Brushes: buy a couple of ordinary (and cheap) household decorating brushes. Use one to prime the baseboard, making sure you clean it thoroughly with warm soapy water after each use. Use another as you work to "sweep up" the fragments of tiles from your project and to keep your work area clean.

Tile sponge: seek out sponges intended for tiling—they hold lots of water when washing off excess grout and don't shred or fall apart as quickly as cheaper, domestic sponges.

Spatula: you will need a spatula to spread the glue onto your baseboard when fixing tiles into position. Plastic spatulas are cheap, widely available, and easy to clean.

Pencils: you will need a variety of pencils of different softness for tracing and transferring your drawings to the baseboard. Always work on your baseboard initially in pencil, then, when you are happy with the result, go over the drawing with a pen to make it more permanent.

Pens: good quality felt- and fiber-tip pens are used to mark cut-lines on your tiles. Use pens containing water-soluble inks so that any marks will be removed when the piece is cleaned up after grouting.

Rulers: transparent rulers are useful when drawing up and transferring your design to the baseboard—although a steel ruler is a must-have for scoring tiles.

GETTING IDEAS

You can find inspiration for mosaic designs almost anywhere. Once you have caught the mosaic bug, it is worth keeping a folder to store images and ideas that you stumble across—pictures or motifs torn from magazines, postcards, a scrap of material, a piece of giftwrap, or a photograph or doodle that you take or make yourself. There are some basic principles for adapting this source material into a design for a mosaic. The main one is to try and simplify things as much as possible—concentrate on color and shapes—and discard complex details that will be impossible to interpret in mosaic.

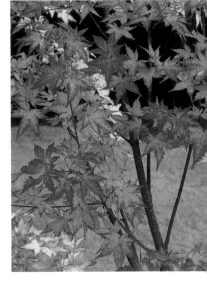

TRACE STRONG DESIGNS

It is probably best to start with two-dimensional sources—unless you have a natural talent at drawing from life. Begin with patterns or designs you find in magazines and books and trace these.

Tape some tracing paper over the original with masking tape, then try using a thick felt-tip pen to go over the main outlines. A thick pen will stop you from being too fussy about detail and will help simplify and strengthen the design. Color this tracing, restricting yourself just to three or four colors—again use strong, thick felt-tip pens. You can even "trace the tracing" to simplify and strengthen the design further.

When you are happy with the tracing, use the techniques described on pages 22–24 to enlarge the design to a suitable size and transfer it to your mosaic baseboard.

▲ Greeting cards are a great source of inspiration, often containing small details or patterns ideal for mosaic work.

▲ Naturally occurring colors and patterns are all around us. The delicate leaf shapes and rich fall colors of this Japanese maple could be translated into a beautiful panel for a garden, giving color all year round.

◄ Try matching tiles to a piece of inspirational material, and you may be surprised at just how many shades are available in tile form.

► Children's toys often utilize strong geometric patterns in bold colors, which will often work well as mosaics.

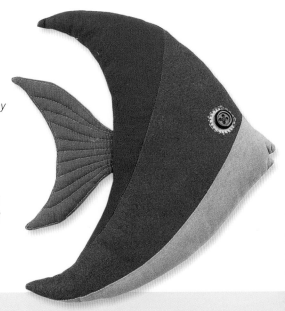

◄ It is interesting to compare a finished piece with its initial sketch. Here the background is not entirely accurate—the tonal contrast between foreground and background is slightly murkier in reality than in the drawing—but it is pretty true to the completed piece, While you can, and probably will, make changes from your initial sketch, it is important to make a good, well-thought-out sketch to work from.

FINDING INSPIRATION

There are many sources of inspiration that you will come across in your day-to-day life. For example, photographs of exotic birds and animals are everywhere—their strong markings and vibrant colors can often be easily adapted into stunning designs.

Textiles are another great source for ideas—the nature of weaving means that many designs have a strong, rectangular structure and are ideally suited to be adapted into a mosaic.

But inspiration need not be too literal—the colors in a picture or a photograph can be breathtaking, suggesting combinations that you might never have thought of. The colors alone might inspire a finished piece that has nothing to do with the original context in which you first saw them.

▲ Fabrics and gift wrap often include simple floral motifs, which can be recreated in mosaic. These samples feature strong patterns that can be traced over.

▼ Clashing colors can work well together, as with this bunch of vibrantly colored artificial tulips.

▼ This tapestry uses close tones and color contrast in a subtle and interesting way.

SCALING DESIGNS

If you are making an original design, it is often easier to work at a scale with which you are comfortable, especially if you will be creating a large mosaic. Whether you use your original design or one from this book, you will probably need to know how to scale any drawing up to the size of your final piece.

TIPS:

GRAPH PAPER

Execute your original design directly onto graph paper to make scaling easier.

MASKING TAPE

Use masking tape to hold down your tracing paper to stop it from sliding around.

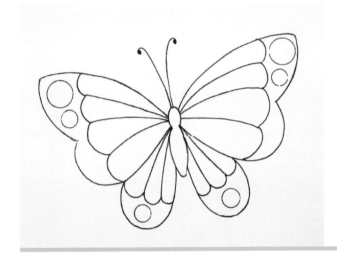

1 To enlarge a drawing to the size you want your finished mosaic to be, you will need to draw two grids of squares. The first grid of squares should be drawn over your original design. In this example, a simple outline of a butterfly has been chosen.

2 If you don't want to spoil the original, draw your grid onto a sheet of tracing paper and lay this over the drawing. (Alternatively, you can work directly onto a photocopy of the drawing.) To make things easier, the drawings for the projects in this book already have a grid in place.

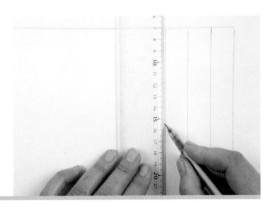

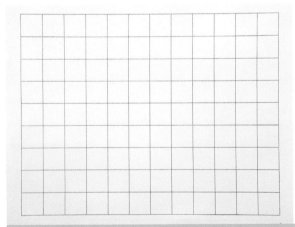

3 The second grid is drawn onto a piece of paper larger than the finished mosaic. (The design will usually require enlarging, so this grid should be made up of squares that are bigger than those of the original design. If, for example, you want to quadruple the size of the original, then each square must be twice as big.) For this second grid, it is a good idea to use tracing paper or a very thin "layout" paper—this will become clear later when you move on to transferring your design.

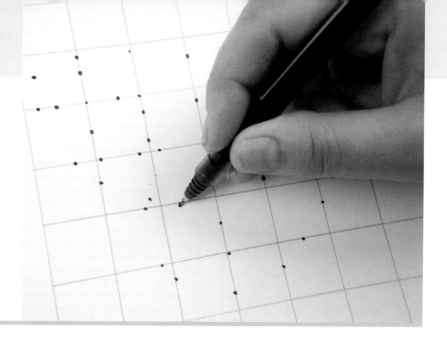

4 To copy the drawing, go to the original and choose one of the main lines or features of the design. Look carefully where and in which square the line begins in the original, then mark the same place in the second grid with a dot. Now follow the line you have chosen and see where it crosses each line on the grid. Draw a dot or small cross in the corresponding place in the second grid.

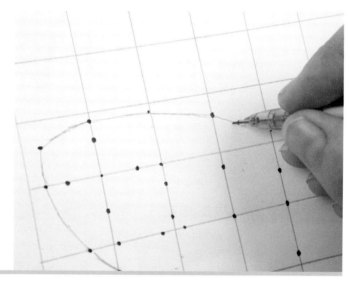

5 Now join these dots to complete the line of the original. Check visually to make sure the original line and your copy look the same—it is easy, particularly at first, to get a dot in the wrong place.

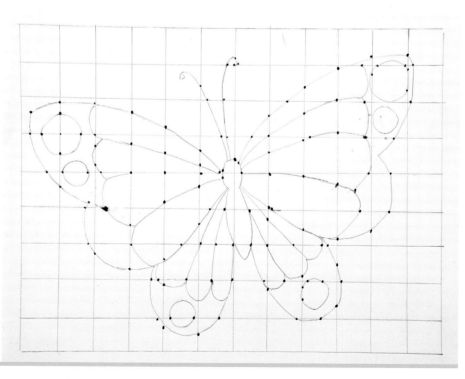

6 Repeat the process for each line from the original, until you have a copy of the whole design on the large grid.

TRANSFERRING DESIGNS

It is far easier to work accurately to your design if you transfer the drawing to your baseboard. Work from your full-sized drawing and make sure you accurately transcribe all elements of your design over.

TIPS:

TRACING PAPER makes transferring your design easy.

SOFT PENCILS (#2 or softer) will transfer carbon better than hard pencils.

1 Once you have enlarged your drawing, you are ready to transfer it onto your baseboard.

2 Begin by turning over the enlarged drawing, then carefully trace over the back of the design using a broad, soft pencil, such as a "#2." If you made the enlargement onto tracing paper, you will find this much easier to do.

3 Turn the drawing the right-side up and place it in the correct position on your baseboard. You will find this easier to do if you tape it down with some pieces of masking tape. Using a hard, sharp pencil, retrace the outline of the drawing. The pencil line that you have just made on the back of the drawing will act like carbon paper, transferring the design onto the baseboard.

4 Carefully pull back the drawing from one corner and check that you have gone over all the lines. (Lay the drawing back down and redo any areas that you have missed.) When you are happy, remove the drawing completely and then go over any faint lines on the baseboard so that you can clearly see the design. You are now ready to begin gluing and laying your tiles.

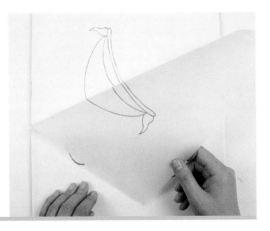

WORKING WITH COLOR

Color is one of the most powerful aspects of the mosaic medium. Mosaic tiles have an extra depth and intensity to their color that no other medium can match. If you hold up a tile against even the brightest painted or printed colors, the tile will always seem to outshine them. Learning to work with colors and exploiting the rich possibilities that tiles offer are important steps in producing good mosaics. But as well as learning how to be bold with color, you also need to master creating more subtle effects in the way you combine tiles together. No matter how big a collection of tiles you acquire, you will always face some limitations. Unlike a painter, you cannot mix or thin and water down your colors to achieve subtle shades or blends.

TIPS:

COMPLEMENTARY HUES
If you have a plain background area to fill, you can avoid boring areas of flat color by mixing different hues, provided that you keep the tones close.

CHOOSE ONE COLOR PALETTE
Sticking to either warm or cool colors in a piece will give it a strongly atmospheric effect.

COLOR WHEEL

The color wheel illustrates some of the important rules of the way colors work when placed together. The colors that are near to each other on the wheel are harmonious when placed together, tending to merge rather than clash. Those on opposite sides are known as "complementaries" which, when placed together, will seem almost to react with and separate from each other. You can experiment with tiles from different positions within the color wheel to see the different results.

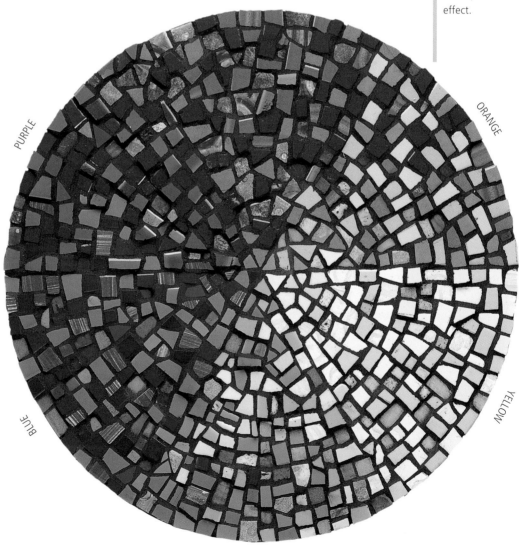

WARM COLORS

Colors have an instant, emotional impact. Warm/hot colors such as red, orange, and yellow give a picture or design an energetic, busy, perhaps even unsettling feeling.

COOL COLORS

Cool colors—blues and greens—have an immediately cool and calming impact, often adding depth to a design. The association with water and nature of the deeper shades of these colors is obvious.

EARTH COLORS

These colors might be described as "neutral" or "earth" colors. They are often used to provide fills or backgrounds that will not clash with other, stronger elements of a design.

MONOCHROME

Sometimes you may want to use a monochrome palette, in which different tones of the same design are used. Although monochrome is often thought of as the variations in grays between black and white, in fact it can be different tones of any color—for example, different shades of pinks or blues. For more information on tone, see pages 72–73.

COMPLEMENTARY COLORS

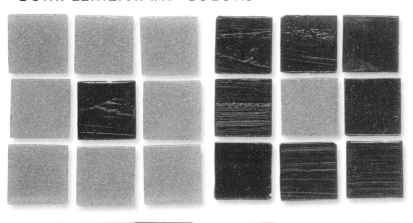

◄ Here, the complementary colors of red and green have been combined in a simple nine-tile arrangement. Look carefully at how the central tile seems to be standing out from the surrounding tiles on the left, but appears to sink into them on the right.

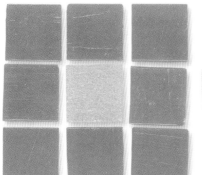

◄ The same phenomenon can be observed here: the yellow tiles on the right appear to be brighter than the single yellow tile on the left.

◄ Here is the same arrangement with the complementaries of blue and orange. Although the same tiles have been used in both examples, the isolated orange tile on the right appears darker than its brothers and sisters on the left.

The vibrancy that complementary colors can produce is used to great effect in the Kingfisher project on pages 80–82. When the tone of complementary colors is very close, the reaction between them creates a shimmering effect.

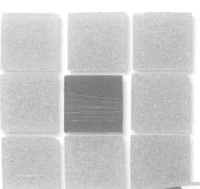

PREPARING BASEBOARDS

Most of the projects in this book use medium-density fiberboard (MDF) as the baseboard on which to mount the tiles. MDF provides a flat, stable surface and is fairly easy to cut with ordinary household tools. It is easily obtained from lumber suppliers and home-improvement stores.

However, MDF is not waterproof. It will readily absorb moisture and then warp out of shape. You should never use it for projects that you want to place outdoors or for pieces that will positioned in a damp environment such as a bathroom. It is also important to prepare and seal MDF before starting work on a project (see Step 3).

MDF varies in thickness from approximately $\frac{1}{8}$ in. to 1 in. (4 mm to 25 mm). For most of the projects in this book, MDF that is between $\frac{3}{8}$ in. and $\frac{1}{2}$ in. (8 and 10 mm) should be adequate, but for larger pieces you may want to use something thicker.

TIP:
BUYING BASEBOARDS
If you plan to use medium-density fiberboard (MDF), it is more economical to buy larger sheets and cut them to size. Hardware stores and builders' merchants generally stock MDF as large boards that are about 8 x 4ft (2.4 x 1.2m). Most stores will cut down a large sheet into smaller pieces for you.

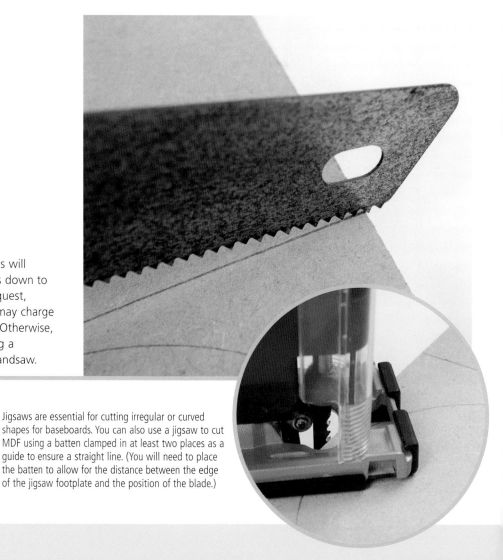

1 Some stores will cut large sheets down to the size you request, although they may charge you to do this. Otherwise, cut to size using a conventional handsaw.

Jigsaws are essential for cutting irregular or curved shapes for baseboards. You can also use a jigsaw to cut MDF using a batten clamped in at least two places as a guide to ensure a straight line. (You will need to place the batten to allow for the distance between the edge of the jigsaw footplate and the position of the blade.)

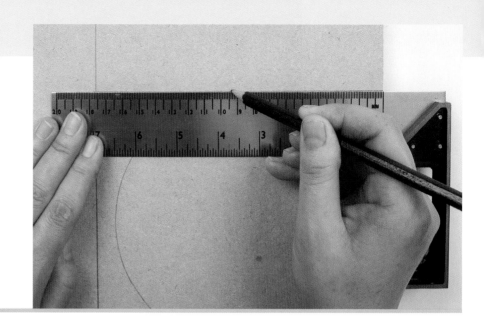

2 Mark up your board and cut out several baseboards at once so as to minimize wastage. A yardstick or straightedge is useful to ensure straight, parallel sides.

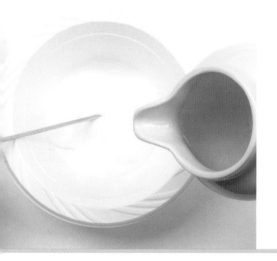

3 Prepare the cut board by sealing it with watered-down white glue. This seals the board and stops it from drying out the glue and the grout too quickly while you work on your mosaic.

If you intend to use a piece as a trivet on which to place hot pans or dishes, you can cover the back with self-adhesive felt, which can be bought at a craft shop.

4 Apply the diluted glue with a large decorating brush and allow the surface to dry thoroughly before progressing to drawing up your design.

PLACING TESSERAE

Whatever material you are using, there are always similar rules about how you should lay your tiles. The overall effect needs to be even and consistent—the gaps between the tiles should be as equal as possible. Unlike painting or drawing, you cannot easily create an outline since you are working with blocks of color. This means you have to create the outline of each shape by carefully cutting and matching the edges of the tiles. You have to suggest this outline and "carry" it from tile to tile, while you think about the bigger picture.

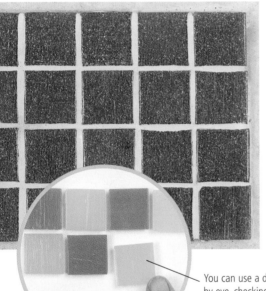

◀ Whatever the size of your tiles, make sure that the space between them is even. It must not be too far apart, otherwise the tiles will appear to be sinking in a quicksand of grout. However, they must not be too close or there will not be sufficient space for the grout. In time, you will learn what is pleasing and looks right. At first, simply enjoy experimenting with small projects and learning how different spacings look.

You can use a drawn grid to place your tiles accurately, but try to do this by eye, checking the vertical and horizontal alignment, and pushing the tiles gently with your fingers to make fine adjustments.

▼ This is the wrong way (somewhat exaggerated) to lay your tiles. The effect does not hold together, and there is no pleasing gridline to the grout. The uneven gaps create a variation in grout thickness that will distract from your design.

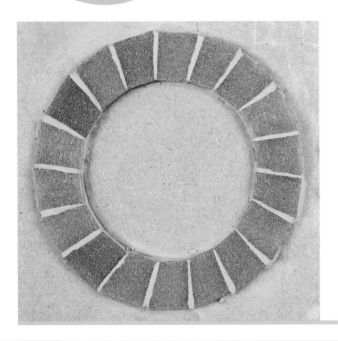

◀ The tiles have been cut to create the outline of a circle— each tile is evenly cut, of similar size, with the edges angled so that they "fit" in an even way. The end result is a strong but harmonious shape.

▶ Here, again somewhat exaggerated, is a shape created without any attempt to cut and fit the tiles into a circle. The end result looks almost accidental, with the outline of the circle lost and no sense of harmony.

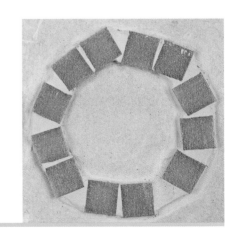

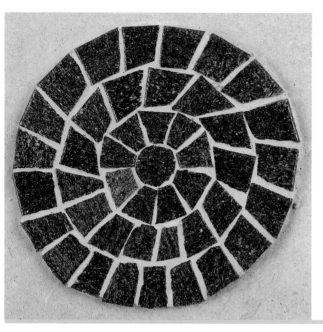

◄ There are various ways to cut filled circles (see Project 14, Circus Seal, on pages 104–105). The classic concentric fill gives a strong, solid result.

► Here, the shape of the circle has no such unity—no real effort has been made to fit the tiles together, so the outline of the shape is fragmented and uneven. When grouted, the end result is even poorer, with meandering and uneven grout lines.

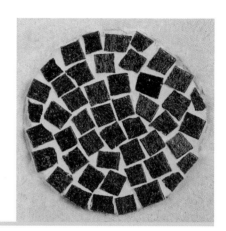

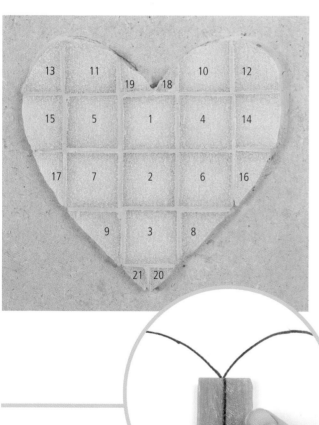

◄ When filling solid shapes, it is important to consider where to begin to lay your tiles, particularly when the shape is strongly symmetrical, like this heart. Here, the first tile to be laid is the one directly below the central dip in the top of the heart. Lay the tiles in the order shown to make sure you get the tidiest shape.

▼ This example shows what happens if you don't plan your starting point. Although the shape that has been filled is identical, the finished heart looks misshapen and lopsided. Because no consideration has been given to the symmetry of the shape, the end result is a confused mixture of different-sized tiles.

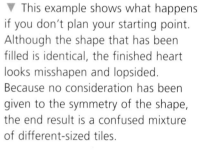

Place the first tile in the exact center of the design (you can mark the tile to be absolutely accurate). Complete the "column" of tiles below this, then work your way outward either side from the center—this ensures that any tile fragments at the edge of the heart are balanced by an almost identical "mirror" piece on the opposite side.

GLUING

To fix vitreous or household tiles to a baseboard, you will find that white glue works effectively, keying to the baseboard, while at the same time gripping even quite heavy tile fragments firmly and permanently.

White glue can be obtained from craft shops or hardware stores. It is best to spend a little extra on a high-quality craft glue, such as a specialty waterproof woodworking adhesive which, when set, will be unaffected by the water-based grouts you will be using to finish the mosaics. Always allow 24 hours between the time you finish gluing down the mosaic and grouting. This allows the glue to set thoroughly; otherwise the moisture in the grout may cause pieces to lift off.

TIPS:

BRUSH CARE

If you have the opportunity to work over a whole day, make sure to wrap your brush tightly in plastic wrap if you take a break. At the end of a session, however, always wash the brush in warm water with a mild detergent.

PLASTIC SPATULAS

can be left and any built-up glue simply peeled off when dry.

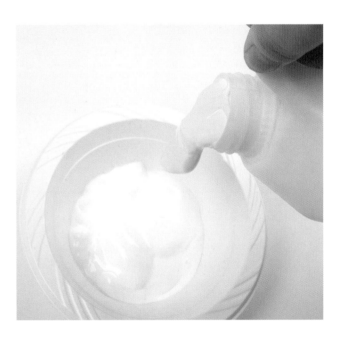

DECANT GLUE

Transfer a small amount of glue to a disposable cup or other container and reseal the main container. This prevents your main stock of glue from drying out—you can keep excess glue overnight if you use plastic wrap to seal the container. Craft glue is normally opaque when wet, but dries clear.

If you mix up too much glue, you can cover the container tightly with plastic wrap—the glue will remain usable for at least a day or two.

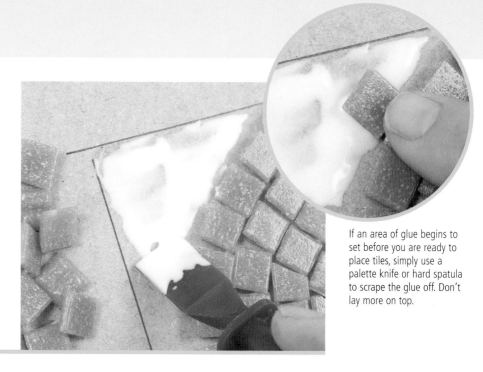

GLUING LARGE AREAS

For areas of larger tiles, in uncomplicated patterns, you can apply glue to the baseboard with a spatula or piece of firm cardstock, then place your tiles into the wet glue. You must pre-cut the tiles, though, and start cautiously so that you don't lay down an area of glue larger than you can tile before the glue dries.

If an area of glue begins to set before you are ready to place tiles, simply use a palette knife or hard spatula to scrape the glue off. Don't lay more on top.

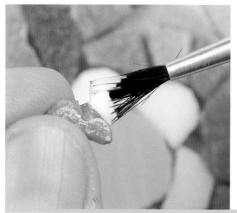

GLUING DETAILS

When working on detailed areas that require smaller pieces of tile, reverse your procedure: dab glue onto each piece of tile with a fine brush, then place it into the design. Try to work neatly to avoid glue being spilled on the surface of the tiles. Glue can be removed later by peeling it off from the smooth surface of the tile.

Use toothpicks to help you push small pieces of tile into position. They are cheap, readily available, and disposable, and they will be far more accurate than your fingers alone!

USE TWEEZERS

To place small pieces of tile accurately, you can use a pair of tweezers, a thin skewer, or toothpick to prod and reposition the pieces before the glue dries.

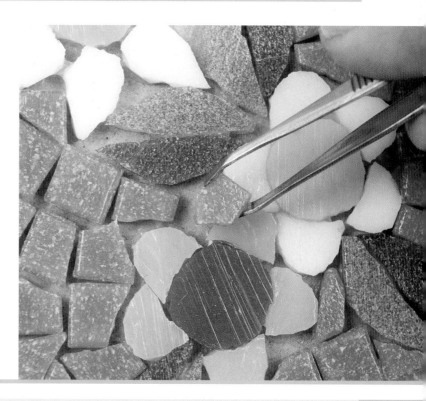

GROUTING

The application of the grout that fills the gaps between the tiles is the final act of creating the mosaic. The grout transforms the separate pieces of tile into a unified, coherent design. When you rub off the excess grout from the surface of the tiles, it is like seeing the design for the first time—it seems to breathe life into the mosaic.

Always be patient and allow the glued mosaic to dry thoroughly before starting to grout. Wait at least 24 hours—if you are unsure, leave it for longer. If you apply grout too soon, it may soften the glue, causing pieces of tile to lift.

GROUT CHOICES

There is a choice of grouts you can use. Most of the projects in this book are for inside use, so a ready-mixed grout that you can use straight from the tub is a good first choice. This grout is most commonly white, although a limited range of colored ready-mixed grouts is available, or you can color it yourself (see opposite).

MIXING GROUTS

You can use grout in powder form, mixing it with water to make a thick, even paste. This is a messy process, although some people think that these types of grout provide a better fill. When mixing powdered grouts, wear a dust mask and gloves and work outside if possible, as grouts often contain lime which is an irritant.

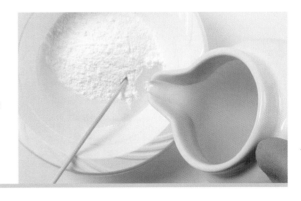

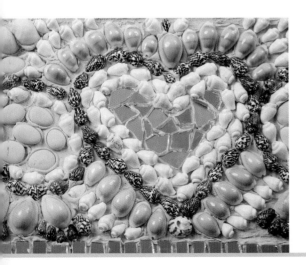

OUTDOOR GROUTING

For a piece that is to be kept outside, you must use a weatherproof grout that is resistant to frost and excessive moisture. You can buy these grouts ready-mixed, but if you need a large quantity, it is better to mix it yourself. Weatherproof grout looks like cement powder and must be used within a few months of purchase, as it will dry out naturally through absorbing moisture from the atmosphere. It is best stored in a dry place, preferably sealed inside a plastic bag.

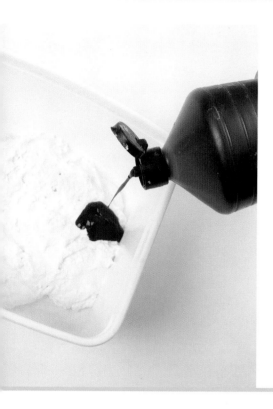

COLORING GROUT

For many pieces, you may want to use colored grouts, as white grout will stand out, particularly when used with darker tiles. Coloring the grout yourself gives you more control over the final color and is more economical. You can use cheap poster and acrylic paints, as well as "professional" colors designed to mix with grout.

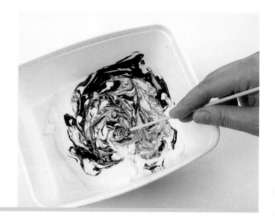

If you intend to color grouts yourself, make a generous quantity, as it is hard to perfectly match a second batch. Ready-mixed grout is commonly white, but to color your own is fairly simple. Ready-mixed is easier to work with, particularly if you don't have a dedicated work space with a sink and good ventilation.

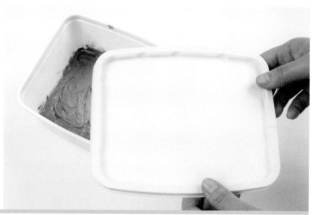

STORING GROUTS

Save ice-cream tubs and other containers to store your mixed grouts. Replace the lid as quickly as possible when using the grout, as otherwise it will dry out quickly. Again, like glue, you can store excess grout for a short period by sealing the mixing bowl with plastic wrap.

GROUT-SPREADING TOOLS

Ready-mixed grout/adhesive often comes with a spreader in the lid made from rigid plastic. This is intended to spread the grout for use as an adhesive. For mosaic work, it is worth buying a selection of small, rubber-bladed squeegees as these are more effective in pressing grout into very small cavities and removing excess grout from the surface of the tiles.

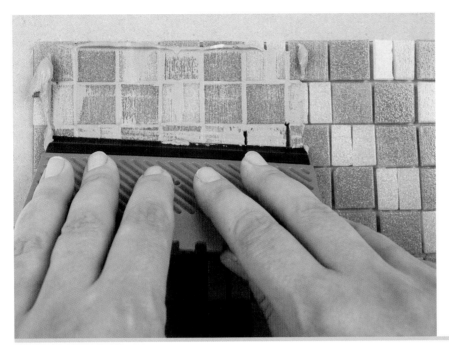

APPLYING GROUT

Use firm pressure on the squeegee to press the grout firmly in between the tiles. Use the squeegee to remove as much excess grout as possible from the surface of the tiles.

CLEANING GROUT

Once you have filled all the gaps between the tiles with grout and removed most of the excess with the squeegee, leave the grout to partially set before wiping over with a damp cloth or sponge. Don't rush the process or you may remove grout from between the tiles, leaving unsightly gaps. Do not dispose of excess grout down the sink as it will accumulate over time and block the pipes.

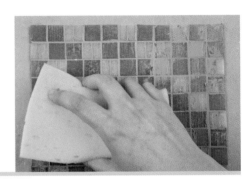

THE FINISHED PIECE

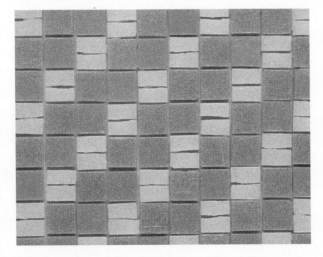

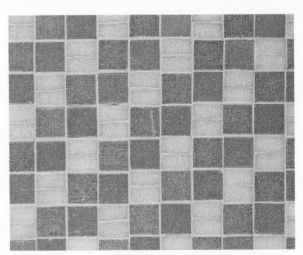

Here you can see the same piece before and after the grout is applied, showing how the grout pulls the piece together.

CUTTING TILES

CUTTING HOUSEHOLD TILES

If you are working with household tiles you can use a variety of tools, as shown in the steps below.

1 Use a metal straightedge and a tile scorer to score the glazed surface at intervals along the width of the tile.

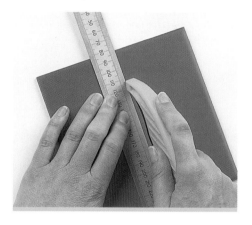

2 Use the tile snapper to break the tile cleanly along each score line.

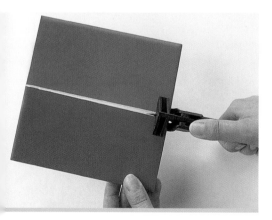

3 You now have a number of strips of tile of equal widths.

Glass tesserae are brittle and therefore liable to shatter when you cut them. You can expect to waste quite a few tiles, particularly when trying to create a really exact shape. Always protect yourself and your workspace from the sharp debris that cutting tiles generates by wearing appropriate clothing and safety glasses and cleaning up the shards as you proceed.

The essential tool is a good pair of tile nippers. Hold the tile nippers in your "best" hand—if you are right-handed, then in your right hand. Hold the tile in your other hand and place it in between the jaws of the nipper—no more than $1/8$ in. (6 mm). Lightly grip the tile with the nippers to hold it, then apply firm pressure on the handle of the nippers. At the same time twist the nippers slightly down against the grip of your other hand on the tile. The tile will split along the line of the blades of the nipper.

Practice quite a few times until you discover the correct mixture of pressure and movement of the nippers to reliably split the tiles. When mosaicing a design that uses lots of similar tile shapes, it is best to cut them in batches—that way cutting the tiles will not distract from positioning and gluing them consistently. You will also find that when you cut lots of tiles in a row that you can more easily repeat the correct cutting technique.

Over the coming pages you will find tips on cutting more complex shapes—but before you move on, make sure that you are comfortable simply splitting tiles into smaller squares and rectangles.

4 Using the tile nippers, snap each strip into square tiles of the same size (with practice you will be able to do this by eye, but at first you may want to measure each square, marking where you are to cut with a wax pencil).

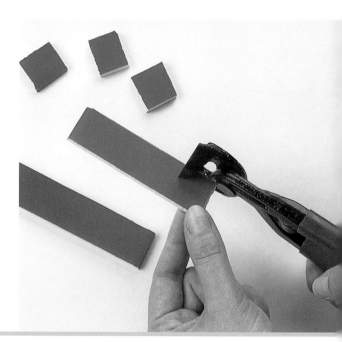

CUTTING TRIANGLES

Triangles are a staple shape of the mosaicist. They are not easy to cut, and you can expect lots of waste. Try not to get frustrated at the number of times a cut will go wrong. Even the most experienced mosaicist will tell you that for every "good" shape they cut, three or four shapes invariably end up in the trash can. Remember, also, that unevenness and variation is part of the charm of mosaics. A background area can tolerate a fair amount of variation in the size and shape of individual triangles, particularly since you can play around with different combinations of tiles before gluing them down. However, there will be some "feature" tiles in any design that are absolutely key to making the whole picture work. It is important that you get these key tiles absolutely right.

TILE GAUGE
This is the sequence of cuts made to split the whole tile into progressively smaller triangles. Lay your own tiles on top of these to see how they measure up.

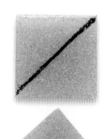

TIPS:

ABOUT NIPPERS
Tile nippers have tiny, sharp serrated teeth that let you "nibble away" at a tile. Always apply even pressure.

HOW NOT TO CUT
Never try to cut from the middle of the tile since it will most likely shatter.

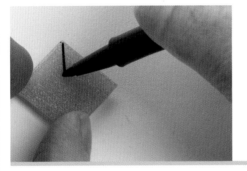

1 **Marking the tile** Select a tile and make sure that the top surface is facing toward you (the beveled edge should not be visible). With a semi-permanent felt-tip pen, mark a diagonal line from corner to corner across the tile. This is the line you will follow when you cut the tile. Later, as you get more experienced, you will be able to make a cut "by eye" without needing to mark the tile.

2 **Making the cut** Hold the tile in your left hand, between thumb and index finger, without obscuring the line you are going to cut. If you are left-handed, hold the tile in your right hand. Take the nippers in your other hand and place a portion of the jaws on the line you've drawn. The other portion of the nippers should overhang the edge of the tile. Squeeze the handles of the nipper with a confident pressure. Don't snatch or try to twist the tile.

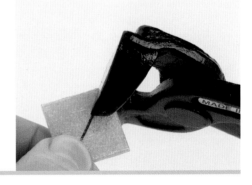
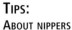

3 Once you have cut the first triangle, draw a bisecting line in order to make another triangle of a smaller size. Cut from the outside in as before.

4 It will then be possible to halve this tile once again to make an even smaller triangle.

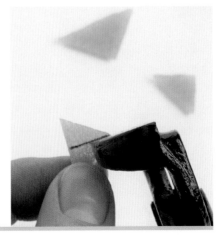

PITFALLS AND HOW TO AVOID THEM
Glass tiles are highly unpredictable. No matter how accurately you follow the cut line with the nippers, the tile still may not cut cleanly and evenly. However, "bad" cuts can often be rescued by using the nippers to "nibble" back to the original line.

CUTTING CIRCLES

Circular shapes require lots of individual cuts. Attempting mosaic designs that require a large number of circles can be physically strenuous work. The trick to cutting circles is to work in a spiral, continuing on from one cut with the next cut running in the same direction, with a shift only in angle. Do not try to work toward the center from opposite sides—you will simply shatter tile after tile.

TILE GAUGE

Test your shapes by laying the cut tiles on top of the outlines below. Start with a square tile that is roughly the size of the diameter of the circle you want.

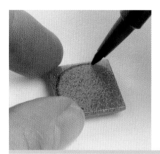

1 **Marking the tile** You will find it very difficult to cut a circle by eye. Always begin by carefully drawing out the circle with a semi-permanent fiber-tip pen on the top side of your chosen tile.

2 **Making the cut** Hold the tile in your left hand. If you are left-handed, hold the tile in your right hand. Take the nippers in your other hand and place them on the tile for a cut to be made from the top outside edge inward to the line of the circle.

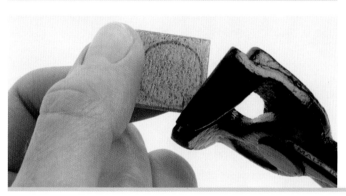

3 Open the nippers, rotate the tile in a counterclockwise direction by a few degrees, then cut inward again from the edge of the tile to continue the curve of the circle. Repeat until you have rotated the tile through a complete circle.

CUTTING SMALL CIRCLES

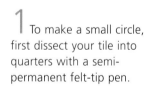

1 To make a small circle, first dissect your tile into quarters with a semi-permanent felt-tip pen.

Rotate the tile for each cut until you have a complete circle.

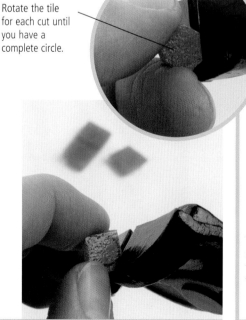

2 Cut your tile into quarter-sized squares, and then make your first cut as above. Refer to the smaller circles used in the flower design on pages 70–71.

3 Rotate the tile in an counterclockwise direction by a few degrees, then continue your cuts in a complete circle.

The smallest circle in this sequence was made by further nibbling the edge of the "quarter-sized" circle.

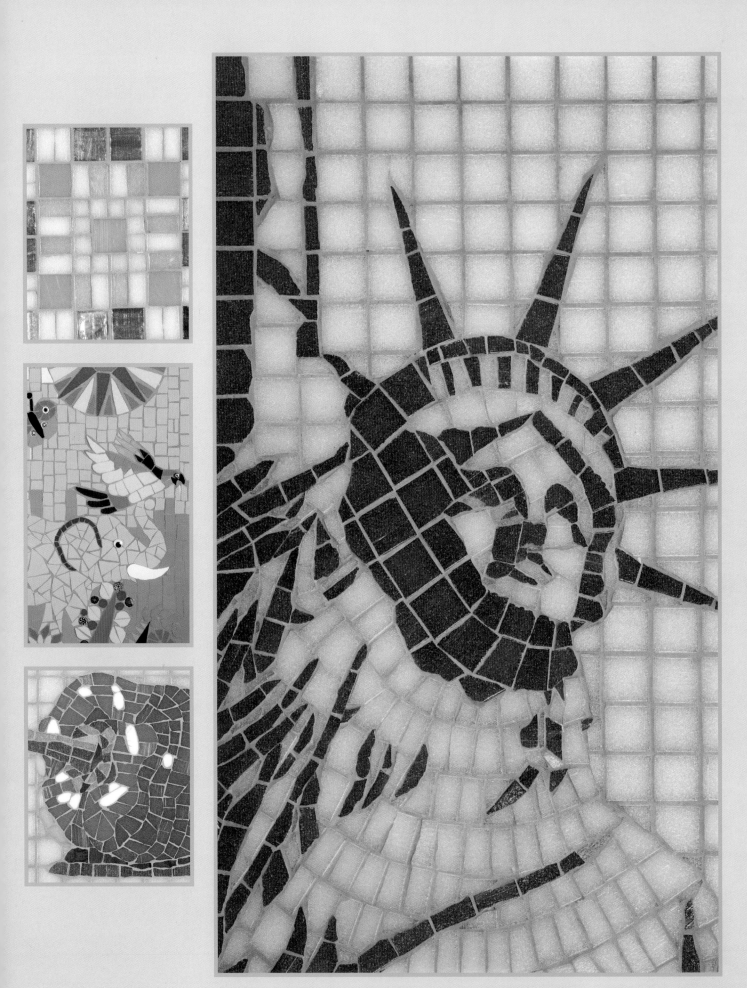

PROJECTS and TECHNIQUES

Now that you're sure of the basics, it's time to get started on some real mosaic projects. This section works by introducing specific techniques, then launches you into projects that will allow you to practice and explore those techniques further. The idea is that each project builds the range of mosaic skills you have at your disposal, as well as giving you the opportunity to complete an interesting and attractive finished piece.

As well as helping you develop the skills of cutting and working with tiles, you will also get to understand more about the principles behind mosaic design. The projects illustrate some key ideas about good composition and how colors and materials work together. Although the projects do get progressively harder, they are all suitable for beginners. Provided you are patient, you should be able to work through as many of the pieces as you want, and, by the end, you will be confident enough to combine what you have learned to attempt your own designs.

TESSELLATION

A tessellation is a pattern where geometric shapes, such as tiles, fit exactly together in a way that can be repeated indefinitely. Simple tessellations are made up of a single geometric shape such as a square or triangle; complex tessellations may combine a number of different shapes that interlock to form a repeat pattern.

Tessellations are one of the basic elements of mosaics, and have been used since ancient times. Simple tessellations of square tiles can provide interest and variation to backgrounds and borders. Even if you confine yourself to the simplest repeating patterns of square tiles, the variety you can produce just through different color choices is remarkable.

TIPS:
Tessellations are everywhere—take your inspiration from natural patterns, buildings, fabric, or even wallpaper.

Cut tiles in large batches, so you have a good stock of similar-sized shapes to work with at any point.

CHECKERBOARD
The basic checkerboard can be done in different colors and sizes—here, uncut tiles have been used in two simple shades of green.

SPLIT SQUARES
A variation is to split alternate tiles in two. However, it isn't quite as easy as it looks—the split tiles need to be trimmed slightly to allow space for grout between them. If you don't trim them, the two "halves" will be wider than the tiles above and below and the pattern won't work. You could also try splitting alternate tiles diagonally.

REPEAT ZIGZAGS
Here, a zigzag tessellation has been created, using quarter-cut tiles of different colors. Using smaller tiles like this is an ideal way to make interesting borders or frames for your designs.

GEOMETRIC LOZENGES

Again, this design works on a very simple grid of squares, but with each square filled with two diagonally cut tiles with colors alternated to give a lozenge pattern.

DOUBLE TESSELLATIONS

Here, small triangles have been cut and arranged in a simple repeat, but again, a double tessellation has been created through the use of color so that the larger blocks of nine tiles form a second repeat of triangles. The alternating blocks are also "positive" and "negative" versions of each other.

BEND THE RULES

Here, the same triangular pattern has been repeated using circular-cut tiles and millefiori. While not strictly a tessellation, the repeat of circular tiles can provide a looser "bubbly" effect that will suit some designs.

PREPARE YOUR GRID

For many tessellations, the grid is just basic squares repeated over and over. It therefore helps to shade in the squares of the grid for the different colors you are using so that you don't get confused and make mistakes when you start to glue the tiles down.

TRY DIFFERENT COLORS

Try playing around with a selection of tiles to make up different checkerboard patterns without gluing them down—use different tones, colors, and finishes to produce different effects. Here, a double tessellation has been produced, with the individual tiles and blocks of nine tiles each forming repeats.

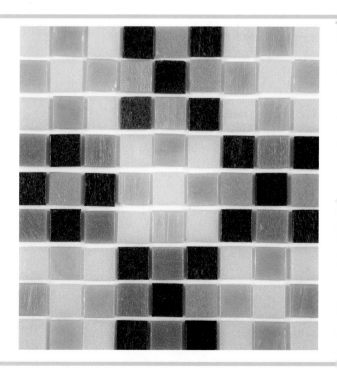

CHECKERBOARD

MATERIALS AND TOOLS

TILES

pale pearlescent pink

pearlescent pink

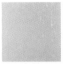
pale lilac

sky blue

copper

orange

ice blue

TOOLS
grease pencil
tile nippers
glue
grout

This is an ideal first piece to master the basic techniques of scaling your design, cutting your first tiles, and learning to position and glue the cut tiles over the drawing on the baseboard. Yet it is also a piece that allows endless variations and adaptation, despite using the most basic cuts. This example uses bright color opposites with pearlized, subtler shades in between.

The design is based around a simple square grid. Each square of your grid should be slightly larger than the size of the tiles you are using, to allow for grout (as a guide, add approximately ½ in. to each side of a standard ¾-in. tile). This measurement is called the "tile square."

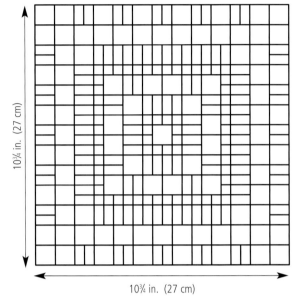

10¾ in. (27 cm)

10¾ in. (27 cm)

▲ **Scaling and transferring the design**
To scale and transfer the design, follow the techniques described on pages 22–24. Design size: 10¾ x 10¾ in. (27 x 27 cm).

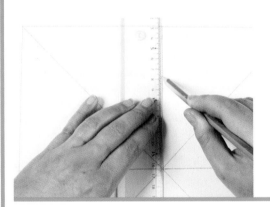

1 **Mark out your design** Using a ruler, draw up the outside square on your primed board. If you are following this design exactly, it will be 13 tile squares high and the same number wide. Then draw in the diagonals from corner to corner to find the exact center of the design. Finally, lightly draw in the vertical and horizontal center lines.

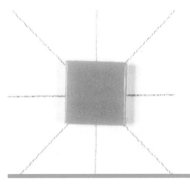

2 **Start in the center**
Place a whole tile at the intersection of the center lines. Position this exactly by eye, or by drawing diagonals across the tile using a grease pencil.

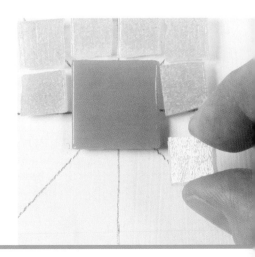

3 **Quarter-sized squares** Surround the center tile with a row of quarter-cut tiles.

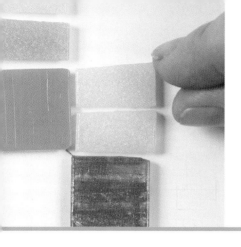

4 **Half-sized tiles** Most of the tiles you use in this design do not need to be cut at all. The other cuts are simple. Here, the tile is just split into two halves: simply place the tile nippers in the exact spot, then squeeze firmly.

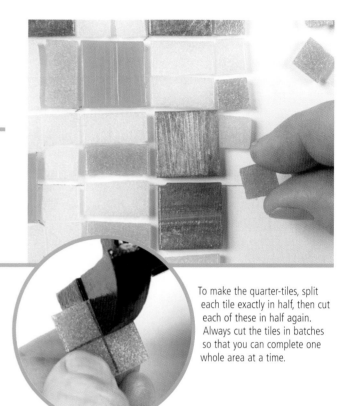

5 A row of quarter-cut blue tiles provides another frame within a frame.

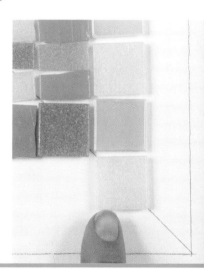

To make the quarter-tiles, split each tile exactly in half, then cut each of these in half again. Always cut the tiles in batches so that you can complete one whole area at a time.

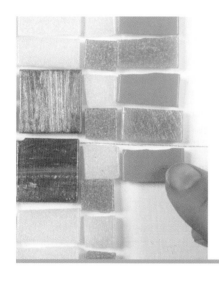

6 As you continue to work outward, the grid remains important. Start each row at the center lines and lay the tiles to the corners, adjusting their spacing before gluing them all down.

7 Always use the uncut edge of tiles on the outside edge of the mosaic, to avoid cutting yourself or others.

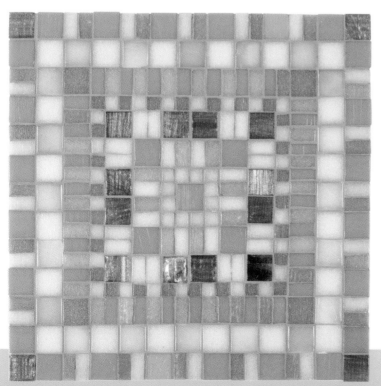

The finished piece is a smart and eye-catching design. The copper tiles add a great finishing touch.

SEE ALSO
Preparing baseboards *pages 28–29*
Placing tesserae *pages 30–31*
Gluing *pages 32–33*
Grouting *pages 34–36*
Cutting tiles *page 37*

PYRAMID FRAME

TILES

sea green

green

ice blue

pale rose

palest pink

yellow

TOOLS

grease pencil
tile nippers
glue
grout

Here is a more complex geometric design, this time based on triangles. It has been used to create a frame, but the design would work equally well as a decorative border on a wall.

Figure out the size of the different triangles, using the "tile square" (see page 44). The frame will be made up of triangles that are three times the diagonal of your tile square along their base, and one-and-a-half times the diagonal in height (see drawing). There is another row of tiles inside this frame that are a quarter of the size of a whole tile. Allow a half-height tile square for this detail.

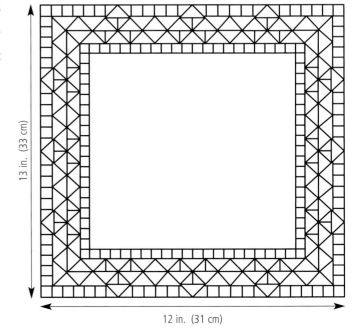

13 in. (33 cm)

12 in. (31 cm)

▶ **Scaling and transferring the design**
To scale and transfer the design, follow the techniques described on pages 22–24.
Size of design: 13 x 12 in. (33 x 31 cm).

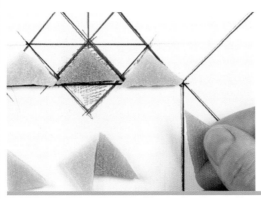

1 **Cutting the tiles** For the triangles along each side of the frame to join perfectly at the corner, the height and width of the frame must be an exact multiple of the width of the basic triangle design. Once you have marked out the design on your board, start from the inside with a row of large triangles made by a diagonal cut of the tiles in your first color. In this example, green tiles that alternate between a darker and lighter tone are used.

2 **Cutting smaller triangles** Fill in the gaps between the first row with pairs of the smaller tiles, alternating every third triangle with a whole triangle in the second color.

To make the small triangles, cut the larger triangles exactly in half again.

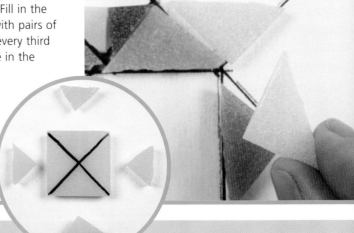

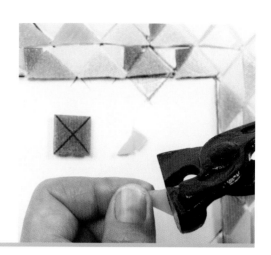

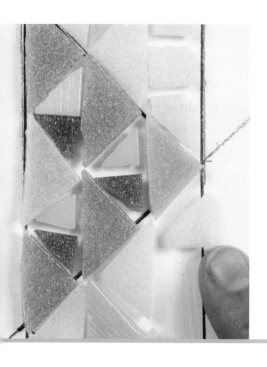

3 Always complete the whole row, filling in with triangles of both colors. Don't lay all the first color tiles, then come back and try to fit in all the second color afterwards—things just won't fit.

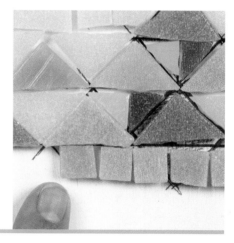

4 **Quarter-sized squares** A row of quarter-tile squares on the outside edges allows you to finish the piece with an uncut edge of tile; otherwise the sharp, cut edge of the diagonal of some tiles would be left facing outward.

5 **Finishing touch** Last, go back and fill the inside edge of the frame with a row of quarter-sized tiles to give a neat inner border.

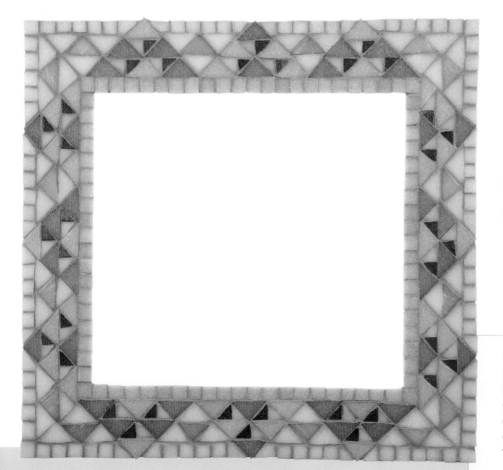

The finished piece is a striking border, and would work very well as a frame for a mirror or picture. Try exploring the effects of different color schemes.

SEE ALSO
Preparing baseboards *pages 28–29*
Placing tesserae *pages 30–31*
Gluing *pages 32–33*
Grouting *pages 34–36*
Cutting triangles *page 38*
Tessellation *pages 42–43*

TECHNIQUE 2 · CUTTING OTHER SHAPES

The simpler projects in this book make use of the basic shapes covered in the previous sections—squares, rectangles, triangles, circles. In this section, we look at slightly more complex shapes. The approach is generally similar—split the tile along straight lines to the size required, then use careful nibbling techniques to accurately achieve the shape you want. As before, always draw the cuts and final shape you are trying to achieve. It can take many years of practice for even the most talented mosaicist to be able to cut shapes "by eye" accurately.

FREEHAND SHAPES FROM LARGE TILES

Household tiles can be great to work with, as they afford a great deal of choice in both the shapes and sizes that you can cut them into.

A tile cutter like this (below) is easily obtained from a hardware store. Not only will it help you to work more quickly and precisely, but it will also encourage you to experiment with strong and bold geometric elements.

To cut tiles along diagonals, a plier-type tile cutter is better. Rest the tile on a flat surface, then score into the glazed surface of the tile using the cutting wheel. Finally, turn the cutter over and use the jaws to split the tile along the scored line.

Once you have cut your tile roughly to size, simply mark out the shape you want, and nibble away at the tile with tile nippers.

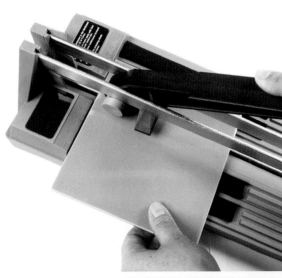

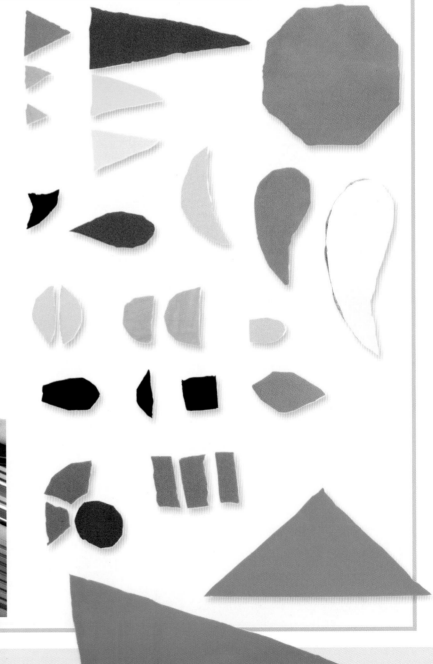

DIAMONDS

A slim diamond shape can be cut by splitting a tile in half, then tapering the ends of the separate halves. These examples have been cut in a straight, angular way to produce diamond shapes. Using the whole tile gives you a similar result, only wider.

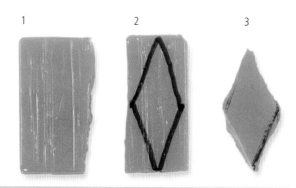

LEAF SHAPES

These leaf shapes are more rounded. Split the tile in half, draw a curved line, then nibble along this a bit at a time to create a curved edge.

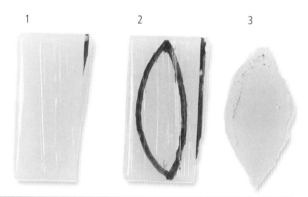

TEARDROPS

The teardrop is a useful shape, both for naturalistic designs and for patterns. Start by splitting the tile in half—the shape is broad and rounded at one end, and sharply tapered at the other.

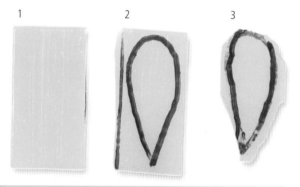

HALF-MOONS

To create this half-moon, split the tile in half, starting from one corner, then just nibble round with your tile nippers, following the curve you have drawn.

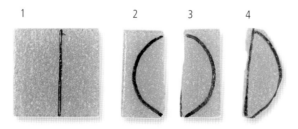

CRESCENTS

These crescent shapes are difficult to cut because you are working into the line of the curve (see box).

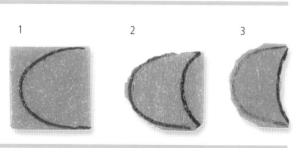

CUTTING CRESCENT SHAPES

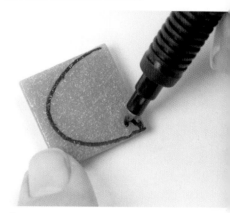

1 Use a whole tile and draw the shape so that you use the complete area—the outer curve should press against three outside edges of the tile. The inner curve should be a shallow notch into the fourth side.

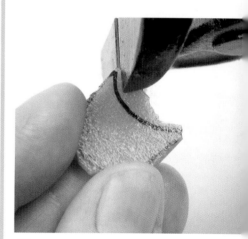

2 Cut the outer curve of the crescent, then grip the tile firmly between your thumb and forefinger, and cut a little at a time along the inner curve with the very edge of the nippers—bite no more than a millimeter into the inner curve with each cut, otherwise you may shatter the tile.

ROOSTER

burgundy
red

coffee

bottle
green

dark cream

metallic
green

dark brown

burnt
orange

millefiori bead,
or googly eye

TOOLS
grease pencil
tile nippers
glue
grout

This is an interpretive piece that creates a stylized representation of a rooster using three main areas, each filled with a different basic cut of tile. These areas flow together to give a sense of the ruffled, slightly disheveled appearance of the farmyard rooster. This piece will help you master the art of scaling your drawings to the size of your workpiece, as well as enabling you to practice some of the most useful cuts undertaken by the mosaicist.

Draw up the outline of the rooster, as well as the "bands" that run through the length of the bird, which you will follow roughly with the different-shaped tiles to give the design its unity. (The nice thing about this design is that you do not have to be too exact. If your tiles depart slightly from the drawing, the end result will still look good. However, try to be as accurate as you can.)

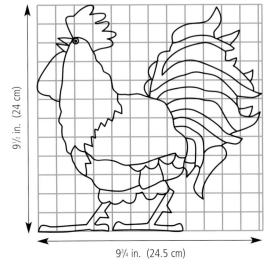

9½ in. (24 cm)

9¾ in. (24.5 cm)

▲ **Scaling and transferring the design**
To scale and transfer the design, follow the techniques described on pages 22–24. Size of design: 9½ x 9¾ in. (24 x 24.5 cm).

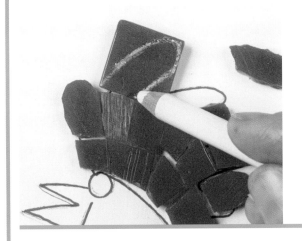

1 **Marking the tiles** Start with the comb and crest of the rooster using blood-red tiles, using a grease pencil to mark where you will cut. The outer edges of these areas are carefully curved, with the tips of the crest cut into an oval shape.

2 Move on to the beak and eye. These are strong punctuation marks or anchors in the design that you can then work from. Use a googly eye, or a suitable millefiori if you have one, or just cut and place a circular tile fragment.

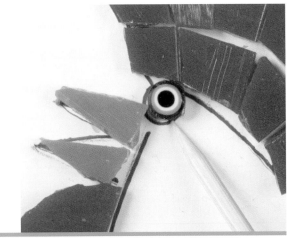

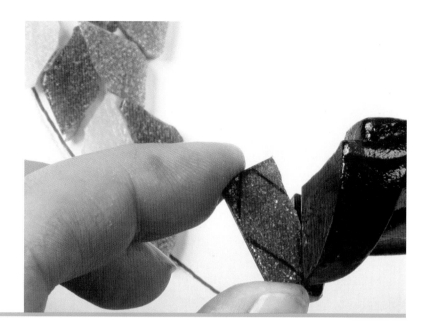

3 The face and neck use leaf shapes. Use a mixture of colors and tones—here a subtle, natural color palette has been used, but brighter, more flamboyant colors would also work. The iridescent tiles give the feathers a soft and luscious appearance. To cut the leaf shapes, use the tile nippers to accurately snap the tiles into two rectangles, and then taper each corner with smaller cuts. Vary the cuts slightly at each corner of the tile for a more organic form.

4 **Cutting circles** Now move across to the main body of the bird, which is filled with circles. Again, in this example a subtle mixture of tones and colors has been used. Cut a number of circles of different sizes so that you can experiment with fitting them together to get a "bubbly" effect.

To cut a "half-moon," first split the tile in two, then nibble away the outer curve.

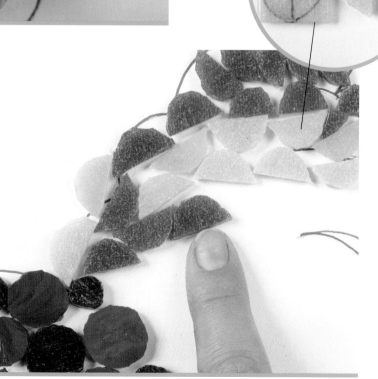

5 **Other shapes** The tail is made of semicircular, half-moon tiles, echoing the colors used on the breast. Keep the tiles within the "bands" of the design, but here you can be more exuberant, creating an energetic cascade of tail feathers.

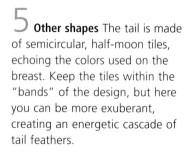

PROJECT 3

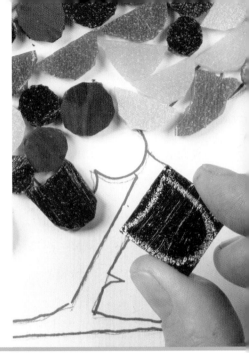

6 The final tiles at the end of the tail feathers have been cut into to give a hooked, flicked-up feel.

7 The underbelly of the bird uses half-tiles cut into a semicircular shape in the same way as the tail. Tiles of the same gentle tone give a softness to this area of the bird. The "skirt" of the rooster is made from whole tiles cut into a U-shape, with a gentle curve cut into the top.

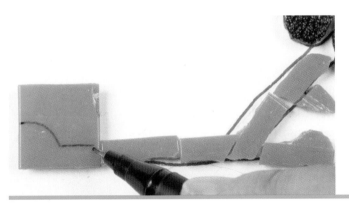

8 **Final touches** Care needs to be taken with the legs and feet—this is another area that anchors the design. With practice, you can cut the toe from one tile.

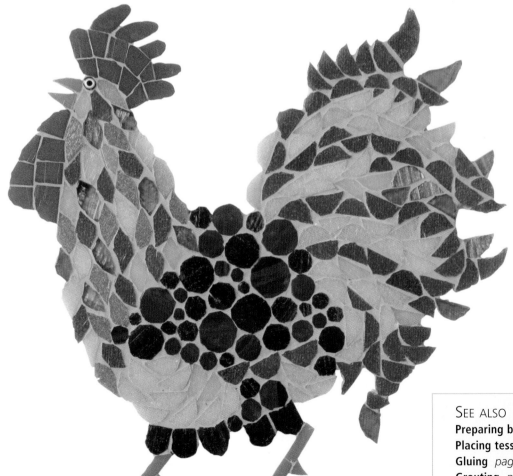

A gray grout unifies all of the elements of this mosaic.

SEE ALSO
Preparing baseboards *pages 28–29*
Placing tesserae *pages 30–31*
Gluing *pages 32–33*
Grouting *pages 34–36*
Cutting circles *page 39*

ALPHABET LETTERS

Mosaics provide a wonderful way to interpret lettering to make really distinctive signs for a house or business. This piece demonstrates how the cut of the tiles and, in particular, the color of the grout you use, can completely alter the appearance and impact of letters of the same style.

Start by scaling up the letters to the size you want. This example shows an old-fashioned style of lettering reminiscent of the theater posters and café signs of nineteenth-century Paris, but you'll come across any number of suitable typefaces by looking in newspapers and magazines. Bold lettering like this—particularly with its flowing, brushstroke design—is an ideal starting point, but blocky, rectangular letters work equally well, although straight edges require a little more patience. Thin, spindly letter shapes are best avoided at first.

This example has been made out of household tiles that are easy to cut and also fill a large area more quickly than glass tiles.

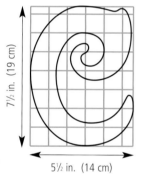

7½ in. (19 cm) / 5½ in. (14 cm)

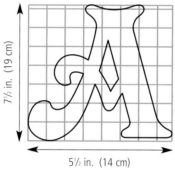

7½ in. (19 cm) / 5½ in. (14 cm)

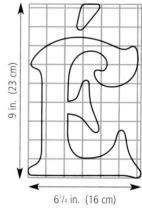

7½ in. (19 cm) / 5½ in. (14 cm)

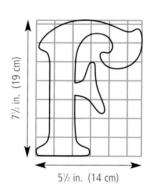

9 in. (23 cm) / 6¼ in. (16 cm)

◀ **Scaling and transferring the design**
To scale and transfer the design, follow the techniques described on pages 22–24. Sizes of design: 7½ x 5½ in. (19 x 14 cm), and 9 x 6¼ in. (23 x 16 cm)

1 **Preparing the tiles** Two different tile cuts and ways of laying them have been used here. The letters "C" and "F" are done "crazy-paving" style with what looks like an arbitrary fill of triangular and jagged tile pieces. Precut a stock of angular shapes. You will find you will still have to cut these further to fit as you work.

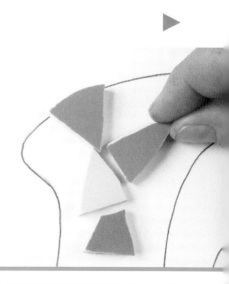

2 **Laying crazy paving** This isn't as easy as it looks—it's a bit like making up a jigsaw puzzle. Using two contrasting colors with this pattern gives a bizarre, harlequin look.

PROJECT 4

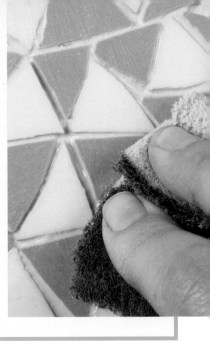

PERFECT GROUTING?
Be patient and allow the grout sufficient time to set. Test the grout by touching it lightly with your fingertips—when it is nearly dry, no grout should lift off.

Don't flood the tiles with water as you clean up, as this will soften the grout. Use a wiping action across the whole face of the mosaic to clean up, don't follow the grout lines or dig into them with your cloth or sponge.

Be gentle! If you rub too harshly, you will damage ceramic tiles or tiles that you have painted (glass tiles are more robust).

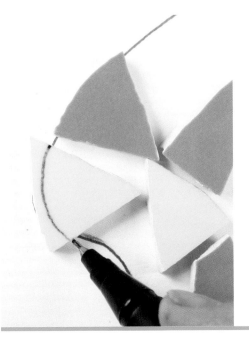

3 **Cutting the edges** Mark your tiles to fit the edges of the letters. For this design to work, the curvaceousness of the letter shapes must be maintained.

4 **Choosing grout colors** While you can buy ready-prepared colored grouts, the range available is limited and expensive. You can create colored grouts with a variety of different paints and pigments, such as children's poster paints. If you do, ensure you make a sufficient quantity to complete the piece and mix it well—it's almost impossible to make two batches where the colors match exactly. Old ice-cream tubs are useful for storing your mixed grouts while working on a project.

Using yellow grout on the "C" makes the piece lighter and busier. Using purple grout completely changes the relative areas of the two colors—making the "F" darker and bolder.

5 **Contrasting style** The letters "A" and "É" have been given a very different treatment, with a neatly laid, flowing, rectangular fill of a single solid red color. The fill is largely made up of rectangular tiles that follow the flow and shape of the letter.

6 **Mark out the cuts in pen** The outlines need to be followed just as carefully as for the harlequin letters. Again, draw on individual tiles to achieve the required accuracy.

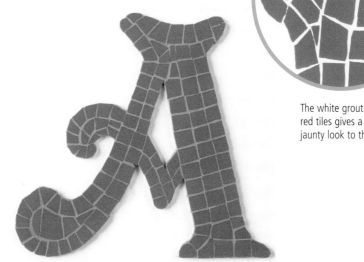

The white grout with red tiles gives a fresh, jaunty look to the letter.

7 The "A" and "É" are also changed by the choice of grout. The gray grout holds the overall shape of the letter together, improving legibility at a distance. A white grout, on the other hand, makes the pattern stand out, adding interest and movement to the letter form.

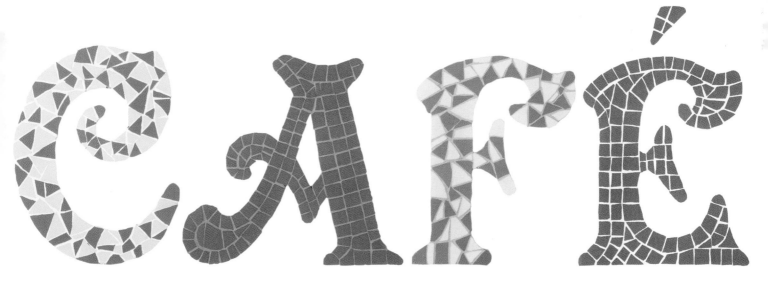

You can clearly see the different results that different grouts produce—the choice of grout is not an afterthought, but should be a considered choice. The wrong choice can ruin all your beautiful work.

SEE ALSO
Preparing baseboards *pages 28–29*
Placing tesserae *pages 30–31*
Gluing *pages 32–33*
Grouting *pages 34–36*
Cutting other shapes *pages 48–49*

TECHNIQUE 3 OPUS

Opus (from Latin, meaning "work") is the word used to describe the way tiles are laid. The way in which the individual pieces of tesserae are cut and arranged dictates the overall rhythm and movement of the mosaic. There are many different "opera"—some simple, others complex. Below are some examples of similar heart-shaped designs, each of which uses a different opus. These show how you can mix different opera in different parts of your design to give a distinct effect.

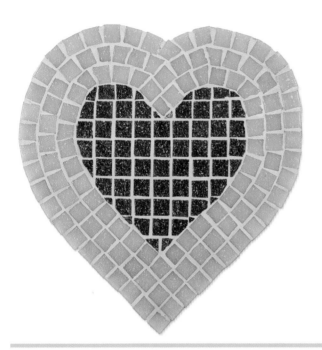

CLASSICAL OPERA

There are two simple opera here. The dark green tiles are laid in a checkerboard as a flat grid. Start the fill of the heart from the middle, centering your first "column" of tiles so that it will be filled symmetrically, then work across. This is known as "opus regulatum."

The opus outside the heart simply follows the outlines in concentric rings. It is a fill that reinforces and strengthens the curvaceous design, while producing a soft and gentle feel. This is known as "opus musivum."

TIP:
LEARN FROM THE MASTERS
Ancient Roman and Islamic mosaics make excellent use of opera. Looking closely at some of these mosaics can be informative and inspiring. It is from these ancient mosaics that the different opera take their names.

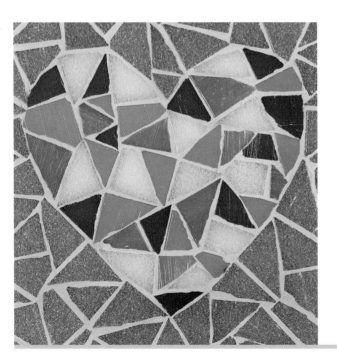

MODERN OPUS

This uses the same opus for the central motif as for the surround—a crackle or random fill known to mosaicists as "opus paladanium"—but uses two very different color palettes for each area, which produces a jarring, edgy feel. When mixing strong contrasting colors in an area, you need to distribute each color very carefully and try different placements before gluing anything down. To get a pattern that is even and balanced requires a great deal of effort, even though the end result appears almost accidental.

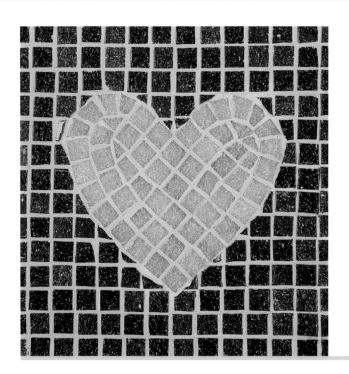

CONTEMPORARY OPERA

Two opera are used here—almost the opposite of the first example. The central heart motif has a fill that follows the outline of the motif, while it is surrounded by a simple checkerboard fill. This combination flattens and neutralizes the background, making the heart seem fuller and in the foreground of the picture, despite the fact that it is in a lighter color.

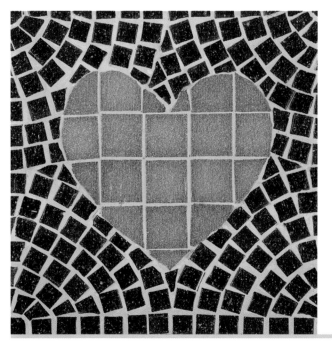

MIXED OPERA

Two different opera are used for the subject and the background. Here, the heart is made to appear flatter by the use of large tiles. Start by centering the first column of tiles horizontally in the heart. The background green is a "fan fill" which extends in from each corner, giving the background an almost undulating effect. These fan shapes are known as "opus circumactum."

MARKING OUT CONCENTRIC CIRCLES
To draw out your fan fill, use a pair of compasses to draw concentric lines from each corner, varying the space between the lines to the width of the tile or tile pieces you are using, also allowing additional room for your grout.

APPLIED TECHNIQUES

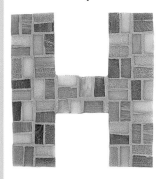

▲ This piece uses alternating pairs of horizontal and vertical rectangular tiles. It is appropriate to the letter's form, so it works well—providing interest without being distracting.

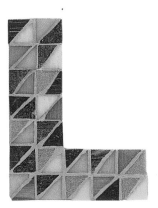

▲ Here, using pairs of 45-degree triangles adds another angle to the "L" shape.

▲ The angle that the tiles face mirrors that of the middle part of the letter, so the opus reinforces the shape's form.

PROJECT 5

OP-ART COW

**MATERIALS
AND TOOLS**

TILES

white

black

TOOLS

grease pencil
tile nippers
glue
grout

The end result of this piece is like an optical puzzle with the irregular, organic shape of the cow emerging out of a stark, checkerboard background. The piece works through the use of two contrasting tile effects—the full squares of the background against the small irregular cuts for the cow's body. Other animals with similar geometric markings could be given a similar treatment—zebras, giraffes, and leopards are some of the obvious candidates.

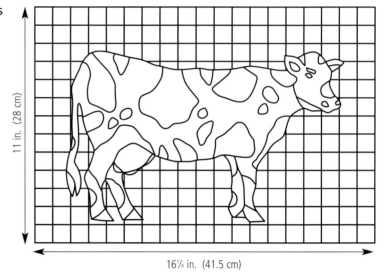

11 in. (28 cm)

16¼ in. (41.5 cm)

▲ **Scaling and transferring
the design**
To scale and transfer the design, follow the techniques described on pages 22–24.
Size of design: 11 x 16¼ in. (28 x 41.5 cm).

1 **Draw out the design** Start with the grid: draw a background grid of "tile squares" (refer back to the first project in this book to remind yourself of how you calculate this measurement), then scale up the drawing to fit the grid. Notice how the rear of the cow and the nose line up with the grid. Placing the outline of the cow accurately in this way will avoid the later need to prepare tiny bits of tile to complete parts of the background checkerboard.

Follow the drawing carefully to mark out the markings of the animal. Notice that around the whole outline of the animal, the black areas of the body meet a white background tile and vice versa.

This is key to establishing the shape of the cow. If you decide to recreate the design yourself for a different animal, then follow the same procedure, making the dark markings border against a light tile. To avoid getting into a muddle, scribble in the "dark squares" of the grid.

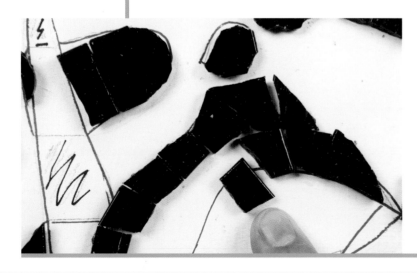

2 **Begin cutting tiles** Start with the inner, black markings on the cow's body.

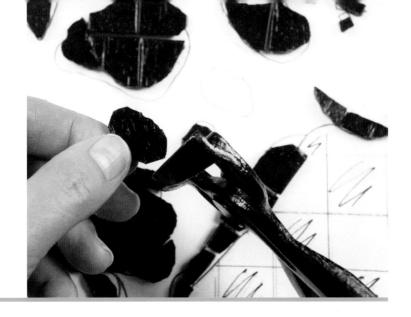

3 The spot markings are made from single tiles, roughly rounded—they don't have to be perfect.

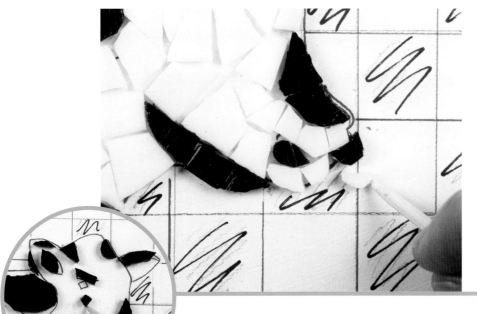

4 The use of just two contrasting tile colors means that there are no midtones or shadows to define the form of the animal. Instead, the way the tiles are cut helps to suggest the form and structure of the animal. Look closely at how the face has been given a faceted, three-dimensional look by cutting the tiles to suggest the jaw, cheekbone, and eyes.

Detail is very important—small fragments of tiles suggest the main features of the face. Getting them right is partly care and partly luck. Be prepared to try several shapes and combinations, and judge which works best.

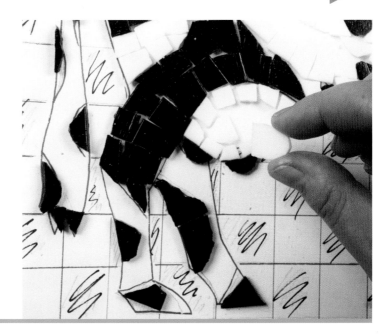

5 Position the white tiles
After you have completed the black markings of the cow, begin the white infill, snaking around the black areas and suggesting the bulk of the cow's belly, and the lines of the haunch and legs.

PROJECT 5

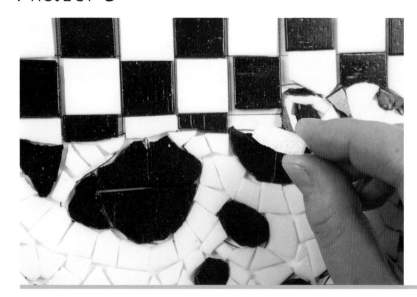

6 **Background** Start on the checkerboard background, cutting into the tiles where necessary to follow the outline of the animal accurately.

7 As you complete the background, the importance of working out the different fill areas in advance becomes apparent. If you draw everything accurately, then the white and black areas of the cow and the background will alternate perfectly.

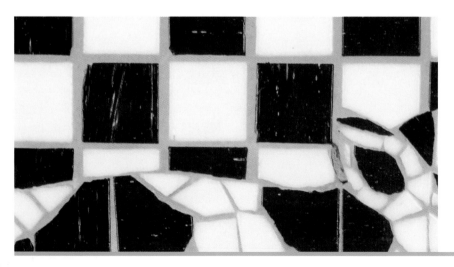

8 **Grouting** Finish off with a grout that is a midtone between the tiles you are using—here a gray is required. White grout would look too "loud," breaking up the shape of the cow (see box, opposite page).

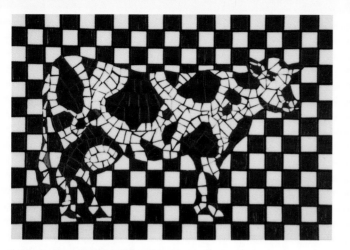
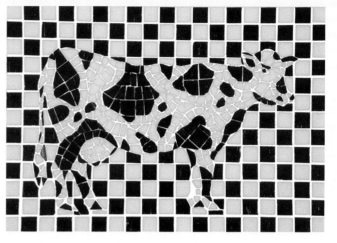

SPOT THE DIFFERENCE?

When placed side-by-side, the very different results produced by using different grouts immediately become obvious. The dark grout on the left noticeably darkens the whole picture, making the blacks of the checkerboard larger, while contouring the white areas of the cow's body. Using a white grout, as on the right, bleaches out the image: the background tiles separate and seem to vibrate, while the features of the cow are somewhat lost.

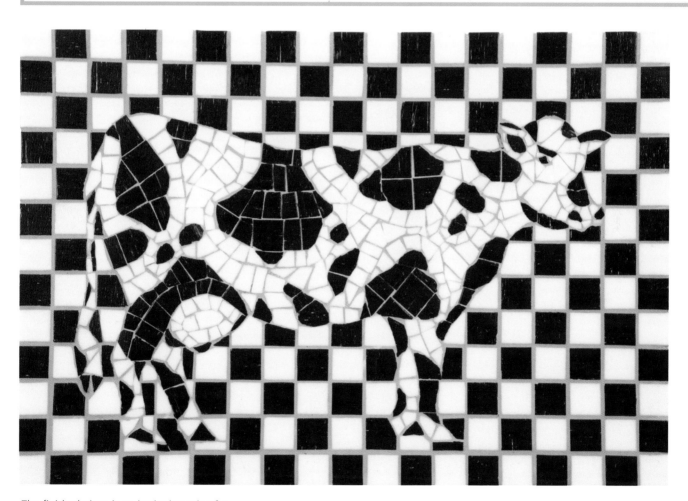

The finished piece is an intriguing mix of a faithful picture of a Friesian cow and a piece of abstract op-art.

SEE ALSO
Preparing baseboards *pages 28–29*
Placing tesserae *pages 30–31*
Gluing *pages 32–33*
Grouting *pages 34–36*
Opus *pages 56–57*

SWIMMING FISH

TILES

pale green

ice blue

sky blue

bright white

blood orange

black

millefiori bead, for eye

TOOLS
grease pencil
tile nippers
glue
grout

To achieve the effect of a fish floating serenely in an ornamental pond, both the body of the fish and the fan-filled background need to be rendered as smoothly as possible. In this example, glass tesserae are used. The black tiles in particular must be cut to give a smooth outline to the fish's markings, avoiding any jagged mismatch of neighboring tiles. Draw each row of the fan background with a compass, and tile each row carefully. A mixture of blues and greens in similar tones will add interest but still preserve the unity of the fan shapes.

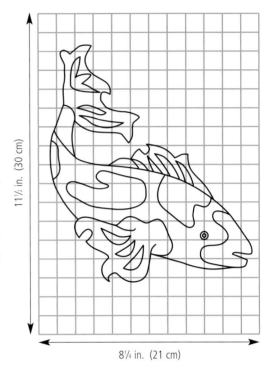

11½ in. (30 cm)

8¼ in. (21 cm)

▲ **Scaling and transferring the design**
To scale and transfer the design, follow the techniques described on pages 22–24. Size of design: 11½ x 8¼ in. (30 x 21 cm).

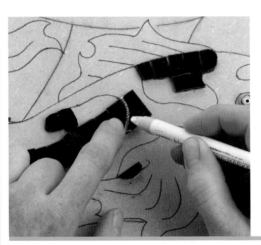

1 **Marking cuts** Place the black tiles first. Use a white grease pencil to accurately mark your cuts.

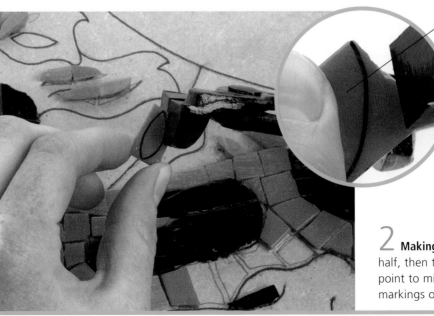

These rounded D-shaped tiles are crucial to achieving the flowing outline and curves of the mouth and the black and orange markings on the body of the fish.

2 **Making cuts** Cut the tiles in half, then taper the ends to a point to mimic the distinctive markings of the fins and tail.

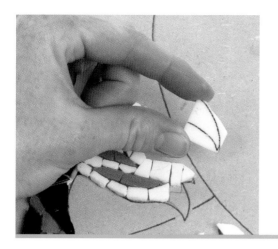

3 Other shapes

The hook-shaped points at the ends of the fins and tail are equally important. Use a black grease pencil on lighter tiles to accurately follow the drawing.

4 Background tiles

Precut lots of quarter-sized tiles for the background. Follow the fan layout carefully but mix the colors in a random way. Once the tiles are glued in place, apply a gray-colored grout using a tile squeegee.

Use a carefully selected millefiori tile for the eye of the fish, or aim to cut an exceptionally perfect circle.

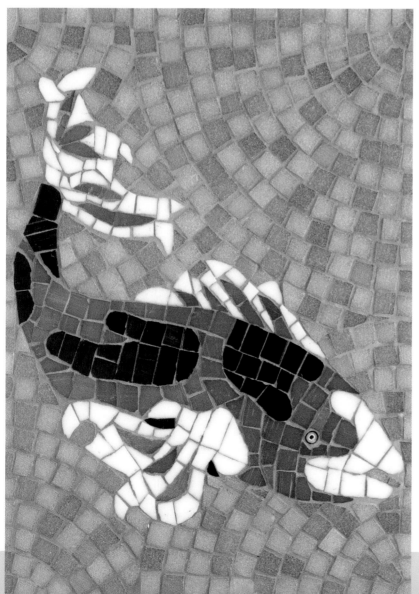

The fan shapes suggest ripples on the water, which creates a sense of movement. The color palette for the fish is much stronger than the water, which makes the fish stand out even more.

SEE ALSO
Preparing baseboards *pages 28–29*
Placing tesserae *pages 30–31*
Gluing *pages 32–33*
Grouting *pages 34–36*
Opus *pages 56–57*

TECHNIQUE 4 CREATING CURVES

Creating flowing curves from small, hard-edged tiles is a challenge that, once overcome, will allow you to take your mosaic work in many rewarding directions. With practice, you can learn to cut tiles so that they fit together into smooth curved shapes, allowing you to attempt designs that are not limited to hard, geometric patterns and fills.

A curve in mosaic works by dovetailing the tiles together—this usually means cutting every side of your tile so that it fits. The outside of the curve is always longer than the inside. This means cutting each tile so that the sides that fit together are wedge-shaped to make the bottom and top shorter or longer, depending on where the tile fits on the curve. With a wiggly line, which side is the inside and which is the outside will alternate, so the shape of each "wedge" will vary. Usually, it is also necessary to nibble the top and bottom of the tile to follow more closely the line of the curve and to reduce the stepped effect that occurs if you leave the tiles straight.

GIVING YOUR CURVE DIMENSION

With a curve in mosaics you should never draw just a single line—your curve will always have a thickness. Treat the curve as a ribbon (or a series of ribbons if you are filling a curved shape). One technique to create curves when drawing out your design is to use two pencils taped together, with another pencil, a matchbox, or some other object to act as a spacer in between them. This twin-headed pencil will allow you to draw parallel, ribbon-like lines on your design.

DRAWING PARALLEL CURVED LINES

The trick is to get the distance between the pencil heads as close as possible to the thickness of the tile curves. Practice first—you need to "drag" the pencils and use your wrist to describe the curve so that the lines remain parallel.

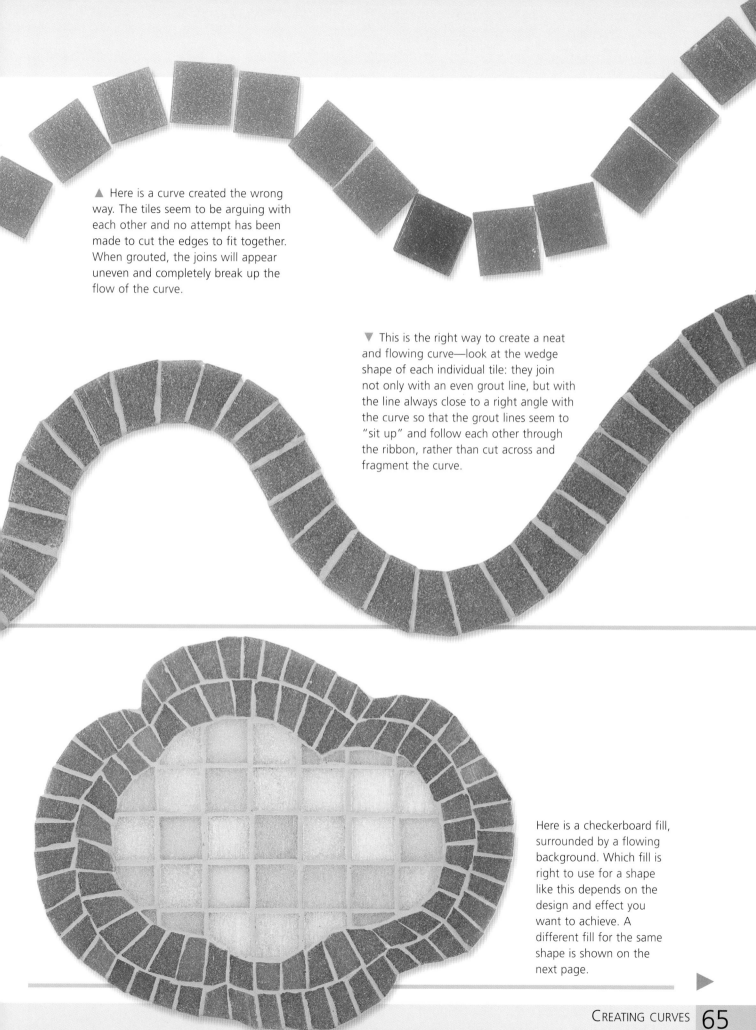

▲ Here is a curve created the wrong way. The tiles seem to be arguing with each other and no attempt has been made to cut the edges to fit together. When grouted, the joins will appear uneven and completely break up the flow of the curve.

▼ This is the right way to create a neat and flowing curve—look at the wedge shape of each individual tile: they join not only with an even grout line, but with the line always close to a right angle with the curve so that the grout lines seem to "sit up" and follow each other through the ribbon, rather than cut across and fragment the curve.

Here is a checkerboard fill, surrounded by a flowing background. Which fill is right to use for a shape like this depends on the design and effect you want to achieve. A different fill for the same shape is shown on the next page.

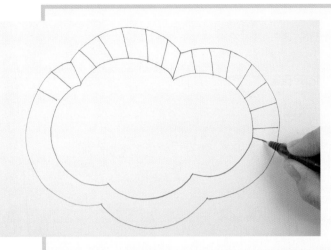

RIBBON FILL

The method of using ribbons of tiles is shown here applied to filling a solid, curved area.

Draw out concentric ribbons to fill the area, and mark where your tiles should fit.

APPLIED TECHNIQUES

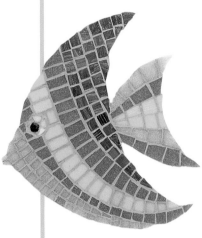

▲ There are lots of curves in this little fish, and they add up to a fun, stylized representation.

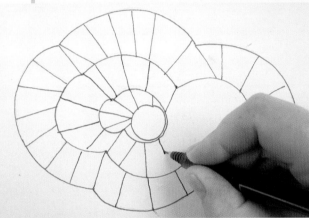

◄ Draw, cut, and fit your tiles a row at a time, exactly as you would for a single curved row.

▼ This fill in this shape against a simple checker-board background fill gives the appearance of a cloud against a flat sky.

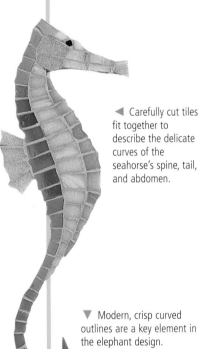

◄ Carefully cut tiles fit together to describe the delicate curves of the seahorse's spine, tail, and abdomen.

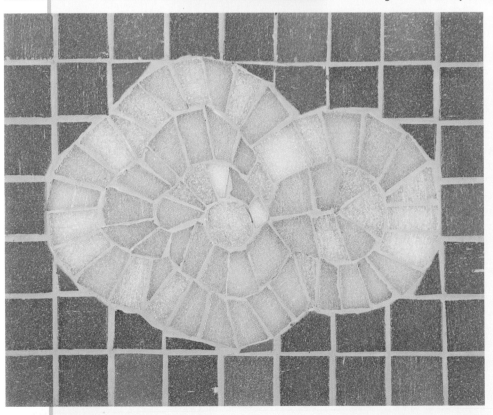

▼ Modern, crisp curved outlines are a key element in the elephant design.

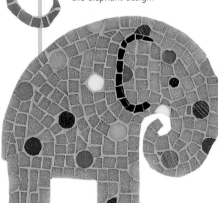

SAILING BOAT

MATERIALS AND TOOLS

TILES

dark brown

sky blue

bright white

dark red

black

palest pink

millefiori beads

TOOLS
grease pencil
tile nippers
glue
grout

This is a deceptively challenging piece that requires the raw materials of mosaic—hard, angular tiles—to be turned into soft, flowing curves. Every element of the design, from the waves to the billowing sail, requires not just the careful cutting of individual tiles, but also the cutting of a sequence of tiles that fit seamlessly together. If you have not already done so, look again at the techniques section on cutting curves (see pages 64–66) to see how to make this work.

The flow of the curves is everything, so concentrate on the "big picture." When you have transferred the drawing onto the board, go over the curves of the waves, the hull of the boat and the sails, using broad, flowing strokes with a soft pencil to really emphasize the curves the tiles will need to follow.

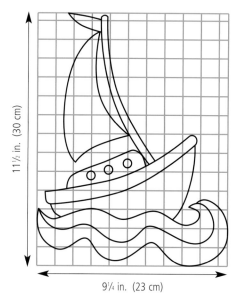

11½ in. (30 cm)

9¼ in. (23 cm)

▲ **Scaling and transferring the design**
To scale and transfer the design, follow the techniques described on pages 22–24.
Size of design: 11½ x 9¼ in. (30 x 23 cm).

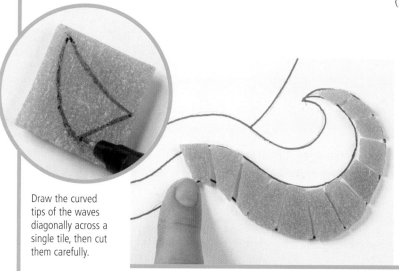

Draw the curved tips of the waves diagonally across a single tile, then cut them carefully.

1 Cutting tiles to fit curves
The whole design rests on the curve of the waves. Start by completing these before you sit the boat on them. The key is to cut the tiles to flow, and the core technique is "dovetailing" the tiles around the curves.

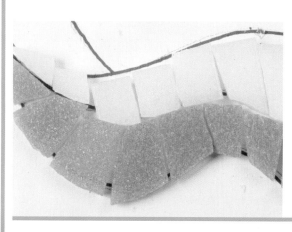

2 The edge of the tile should always be longer on the outside edge of the curve and shorter on the inside. That way, the tiles seem to expand and contract through the flow of the curve in an organic way, rather than distract from the flow if cut and positioned in a more random way.

PROJECT 7

3 **Lay the tiles for the hull** Sparkling brown tiles give the effect of varnished wood grain. Achieve the effect of the individual planks by concentrating on the horizontal curves, just as you did with the waves.

4 **Marking cuts** Using a grease pencil, mark the rounded ends of the bow of the boat to ensure accurate cutting.

Here, millefiori tiles have been chosen to suggest the portholes. You could also cut roughly circular fragments of mirror glass.

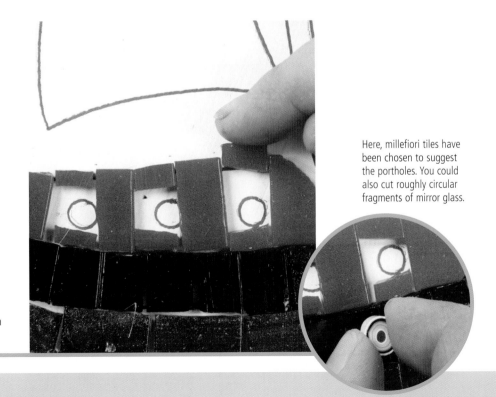

5 **Add detail** The cabin and portholes are kept simple by leaving square apertures in which to place the portholes.

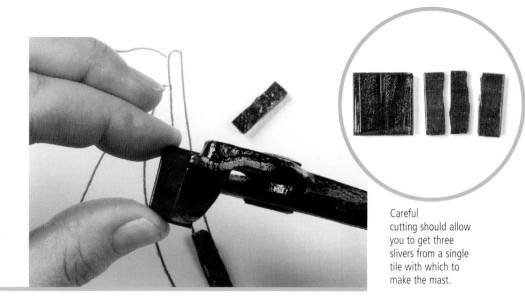

7 The mast needs to be kept thin and elegant. Take extra care to match each section and to taper the ends to give a flowing, bowed shape.

Careful cutting should allow you to get three slivers from a single tile with which to make the mast.

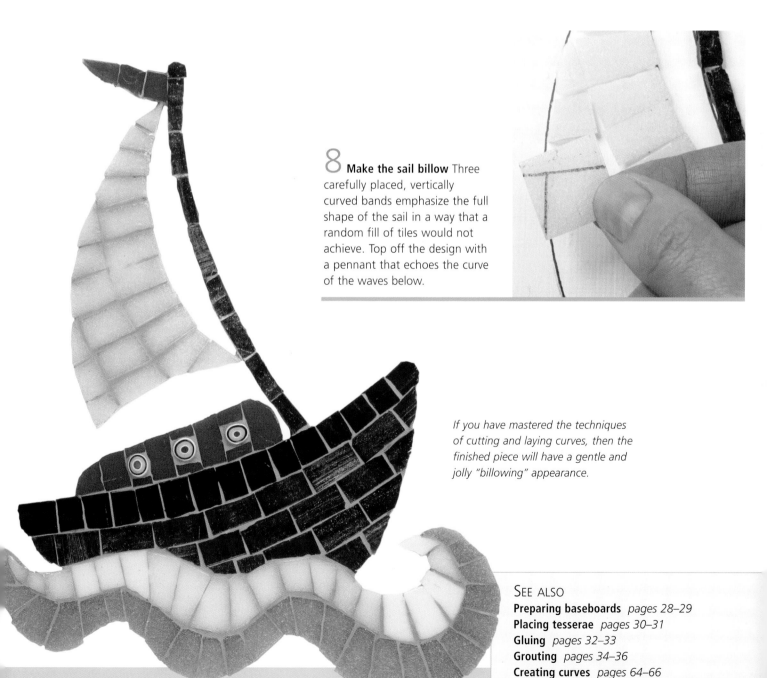

8 Make the sail billow Three carefully placed, vertically curved bands emphasize the full shape of the sail in a way that a random fill of tiles would not achieve. Top off the design with a pennant that echoes the curve of the waves below.

If you have mastered the techniques of cutting and laying curves, then the finished piece will have a gentle and jolly "billowing" appearance.

SEE ALSO
Preparing baseboards *pages 28–29*
Placing tesserae *pages 30–31*
Gluing *pages 32–33*
Grouting *pages 34–36*
Creating curves *pages 64–66*

FLOWER

TILES

ice blue

rose

tangerine

dark red

khaki

putty

palest pink

TOOLS

grease pencil
tile nippers
glue
grout

The flowing organic form of the flower is hugged closely by the curving, soft-pink background. Look carefully at the photograph of the finished piece to see how two sides of the glass tiles are cut to create even curves. The petals are given emphasis by tiles cut in a hooked shape to give the rows more of an arch.

▶ **Scaling and transferring the design**
To scale and transfer the design, follow the techniques described on pages 22–24. Size of design: 11½ x 8¼ in. (29 x 21 cm).

11½ in. (29 cm)

8¼ in. (21 cm)

Cut a tile in half and taper the edge into a pendant shape from each side. Cut all of these pendant shapes in advance, so that you can try different combinations to balance any slight discrepancy in their individual sizes before gluing them down.

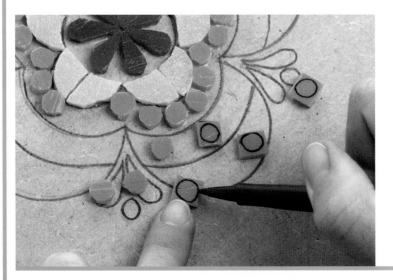

1 **Cutting the tiles** Each putty-colored petal is cut from two whole tiles that are mirror images of each other.

2 **Quarter-tile circles** To make these small circles, first cut your tiles into quarter-sized squares as described on page 37. Then carefully nibble away at the shape in a spiral until you have a circle.

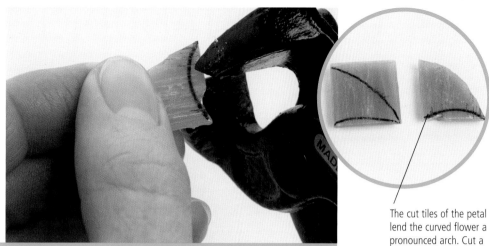

3 Using the edge of the tile nippers, nibble out the inward curve of the hooked petals.

The cut tiles of the petal lend the curved flower a pronounced arch. Cut a curve into both edges of the tile to give it this "hooked" shape. Cutting a curve into the bottom edge of a tile can be tricky and may require patience and practice.

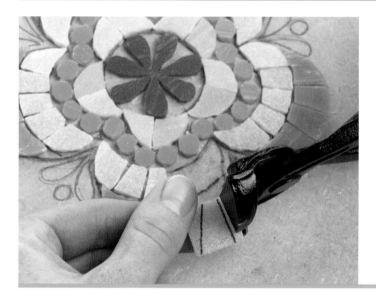

4 **Fan shapes** Draw tapered lines, then cut along them to make these fan-shaped pieces for the two outer rows of petals.

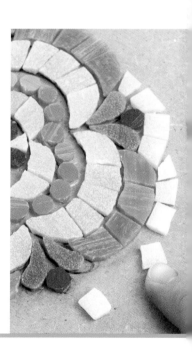

5 **Background** Cut a stock of quarter-sized tiles and lay a ring that carefully follows the outline of the design. Add additional rings, working outward until the background is completely tiled.

Gray-colored grout has been used to complete the mosaic.

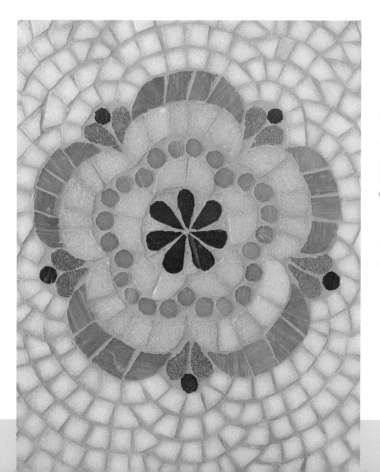

SEE ALSO
Preparing baseboards *pages 28–29*
Placing tesserae *pages 30–31*
Gluing *pages 32–33*
Grouting *pages 34–36*
Creating curves *pages 64–66*

UNDERSTANDING TONE

As well as understanding the way different colors work together, it is important to understand the importance of tone. Tone is, essentially, the brightness of a color. Using contrasting tones in areas of a design or picture gives a clearly defined separation, allowing the areas to stand apart from each other. Using similar tones makes areas merge, even when the colors are quite different. Tone also lends depth to the flat surface of a picture. Conventionally, softer, lighter tones suggest greater depth and distance than strong darker elements, which appear to be closer to the viewer.

USING DIFFERENT AND SIMILAR TONES

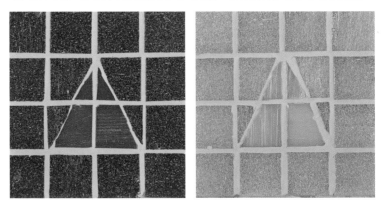

Tone is essentially the lightness or darkness of a color. When similar tones of different colors are placed together, the areas appear to merge together.

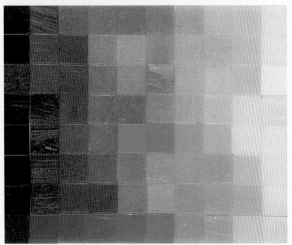

TONAL DIFFERENCE

Here, tiles have been laid out in vertical bands of the same tone. When the image is reproduced in black and white, you can see the tonal differences (and similarities) of the different tiles more easily.

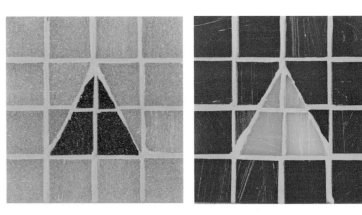

When tiles of different tones are used, the areas are far more distinct. The blue triangle appears to advance from the lighter-toned background, while the pink triangle seems to recede from the darker-toned surrounding tiles.

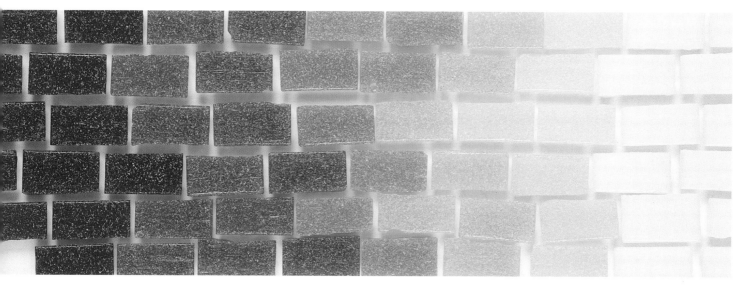

BLENDING TONES

Tiles of the same color but different tone have been combined in this piece to give a blended fill, the tiles lightening from left to right. By staggering the positions of the tiles so that you can slightly offset the vertical rows, you can make the blend smoother, removing the sense of steps you would get if they were arranged in neat rows. (This technique is used in the Jungle Menagerie project on pages 112–117 to give depth and interest to the background sky.)

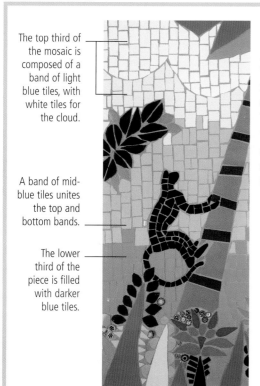

The top third of the mosaic is composed of a band of light blue tiles, with white tiles for the cloud.

A band of mid-blue tiles unites the top and bottom bands.

The lower third of the piece is filled with darker blue tiles.

BACKGROUND INTEREST

In the Jungle Menagerie project, on pages 112–117, the background tone is structured to enable the composition to work better. The eye is drawn up through the tones from the darkest at the jungle floor, right up to the lightest, in the clouds.

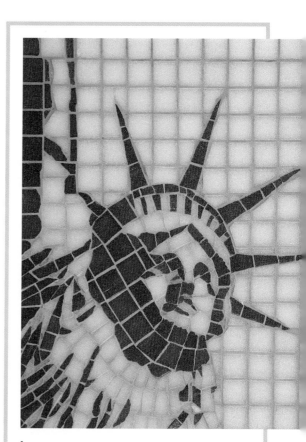

LIGHT AND SHADOW

The Statue of Liberty project on pages 74–76 uses just two different tones of green to convey the falling of light onto the statue. It is a simple but very effective technique that can be applied to many projects.

STATUE OF LIBERTY

MATERIALS AND TOOLS

TILES

ice blue

mint green

bottle green

TOOLS
grease pencil
tile nippers
glue
grout

One of the most instantly recognizable and iconic monuments in the world, this design has been adapted from a photograph and the figure simplified to just two tones of green, with a surrounding third color of blue. Green was chosen because it is in keeping with the color of the statue itself. Alternatively, you could use black and two tones of gray to give the effect of a black-and-white photograph.

If you don't have a computer, you can achieve a similar effect by enlarging an original picture on a photocopier and using contrast controls to get the same effect (you may find making copies of copies is an effective way of simplifying the image).

Alternatively, you could trace the image using a sheet of wax paper or thick tracing paper, and judge by eye the division between the light and dark areas (half-closing your eyes will help you simplify the image).

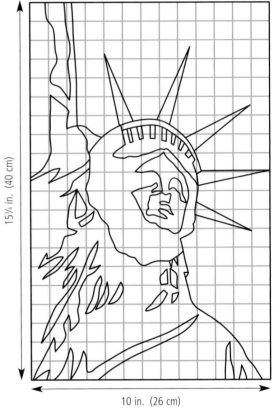

15¾ in. (40 cm)

10 in. (26 cm)

▲ **Scaling and transferring the design**
To scale and transfer the design, follow the techniques described on pages 22–24.
Size of design: 15¾ x 10 in. (40 x 26 cm).

POSTERIZING YOUR IMAGE
You can work from an original photograph in a number of ways. If you have access to a computer, then you can manipulate a digital image using a simple "paint" or "photo editing" package. If you don't have access to a computer, try making photocopies of copies until the desired effect is achieved.

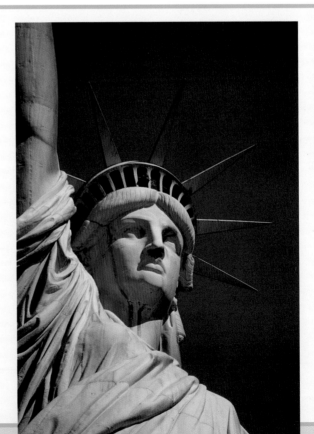

Open the picture in the program (you can use a scanned photo or a copyright-free one you find on the Internet). Save a copy of the image to a black-and-white or "grayscale."

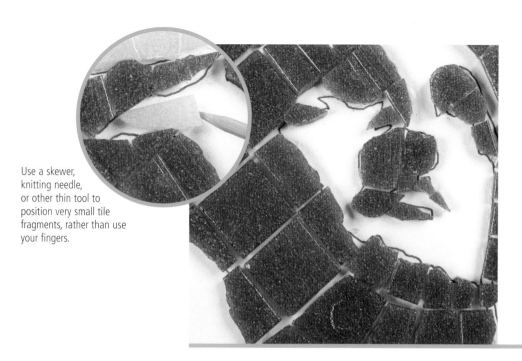

Use a skewer, knitting needle, or other thin tool to position very small tile fragments, rather than use your fingers.

1 **Begin cutting tiles** Start with the features of the face using the dark green tiles. This area is the most crucial to get right and you must cut the tiles absolutely accurately. Redo each piece as many times as necessary until it is exactly right.

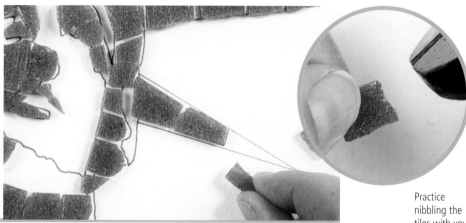

2 **Create form with the darker tone** Once the dark green areas of the face are complete, use the same color tiles on the crown. Again, you will need to make very accurate cuts to get a good, sharp line to the rays of the crown.

Practice nibbling the tiles with your nippers—some of the tiles around the chin and hair have been made deliberately ragged.

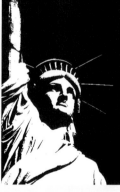

Use the brightness and contrast controls of the program, turning both up to 100 percent (the image will turn completely white and disappear)...

...then, leaving the contrast at 100 percent, slowly lower the brightness so that the features of the face begin to reappear.

Play around with the brightness level until the features of the face are strongly defined, then save the image under another name (so that you can still use the original image if you want to go back and change it).

Now print out the original picture and scale this as you would a normal drawing. Use this to give you the outline of the statue and the prongs of the crown. Then print and scale your "high-contrast" picture to give you the outline of the dark areas of the face, arms, and material of the robe.

3 **Create form with the darker tone** Now continue with the dark green of the drapery, pointing the end tiles to suggest the sharp folds of the cloth. With the dark tiles complete, turn to the lighter shade of green. For the neck and body, use rectangular half-tiles in sweeping arcs to give the figure form. For the strong vertical of the arm, whole tiles have been used.

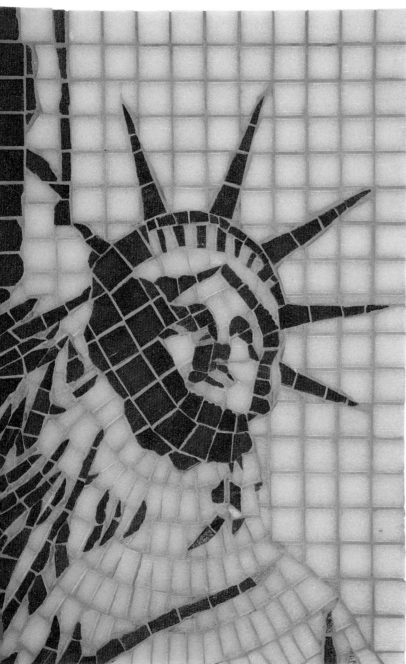

4 **Background** Again, the background is a simple checkerboard of whole tiles. A mid- to pale blue has been used. Experiment with different shades before you begin to cut and stick the tiles down. Too dark a blue will clash with the dark green, while if the shade is too pale, the outline of the light green areas will be lost.

Once the tiles are glued in place, apply a gray-colored grout using a tile squeegee.

SEE ALSO
Preparing baseboards *pages 28–29*
Placing tesserae *pages 30–31*
Gluing *pages 32–33*
Grouting *pages 34–36*
Understanding tone *pages 72–73*

COLOR ALTERNATIVES

As your confidence in your mosaic ability grows, you will want to tackle more complex pieces and begin to adapt each design you attempt to make it uniquely your own. One of the easiest ways to fundamentally transform any design is to simply alter the color palette that you use. The variety of results that you can produce by taking the same design and executing it with different colored tiles and grouts is almost infinite.

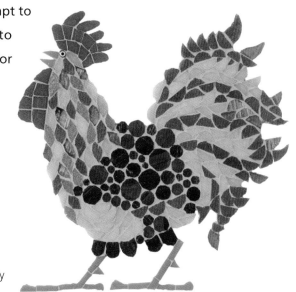

▶ The original of the rooster (see page 50–52) uses a very naturalistic color palette of earth tones—olive greens and warm browns. This subdues what is quite an exuberant design in terms of the tile shapes employed—the bird's body is a mass of circular bubbles, while the tail is an unruly cascade of semicircular and triangular fragments.

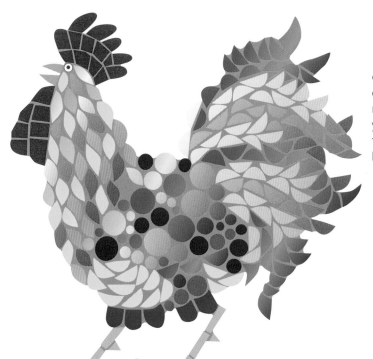

◀ Without altering any element of the design other than the colors of the tiles, very different effects can be achieved. This color palette retains some naturalistic feeling but uses a mixture of extreme, vibrant blues, golds, oranges, reds, and yellows. The design immediately becomes more exotic, while the stronger contrast between the different areas of colors highlights the flourish of the bird's tail.

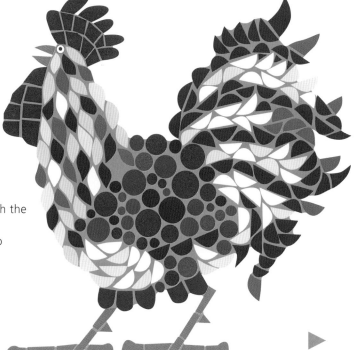

▶ Here a very different approach is adopted, although the color palette is equally rich. This red, white, and blue version uses just three bold colors, and can be used to make a point in a patriotic setting. By minimizing the variation in the tiles used for each color, the rooster almost becomes a flat, graphic motif.

TECHNIQUE 6

Here are two alternative color choices for the Op-art Cow (see pages 58–61). Before embarking on any radical rethink of the colors of the piece, always experiment with different color combinations by playing with and positioning uncut tiles together.

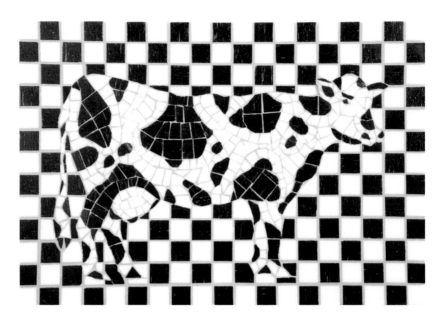

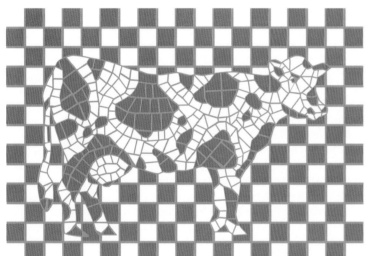

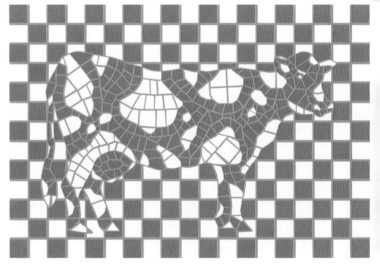

▲ ▶ Take a tile of one color and surround it with a background of another very different color. Switch the foreground and background colors around to see the different effects.

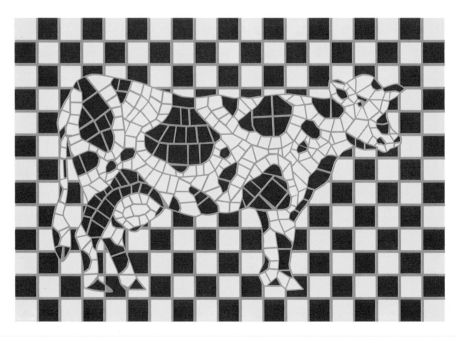

▶ Try mixing up two or three different colors at random—sometimes the most unexpected combination will work, though you probably won't be able to get away with every mixture of colors!

CHOOSING GROUT COLOR

Gray grout is often seen as the safest choice for grouting a mosaic piece—its neutral color and tone means that it will safely complement almost any mixture of tiles without any unpredictable clash.

However, using colored grout, if thought about carefully, can add an extra intensity that will enhance many designs.

◄ A naturalistic color palette makes for a representative piece here.

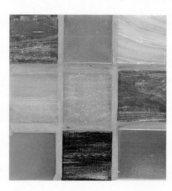

▲ Here, three different colored grouts have been used—white, gray, and blue—on the same colored tiles. You can immediately see the different effects produced by each grout color.

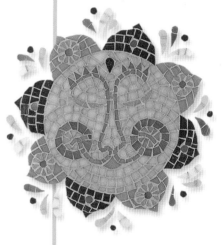

▼ This smiling sun makes great use of both toning and complementary colors.

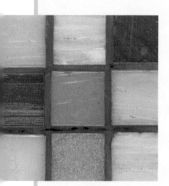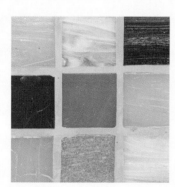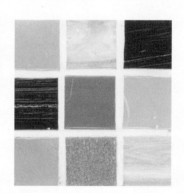

▲ Here, black, gray, and white grouts have been used on warmer-colored tiles. Notice how the white grout completely chills the colors.

▼ This image uses just four colors in very clearly defined areas, and works well.

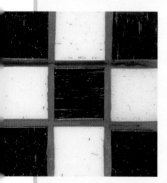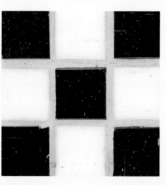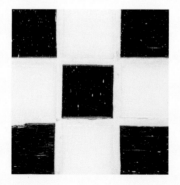

▲ Black, gray, and white grouts used on black and white tiles have probably the most dramatic effect—the gray grout seems to balance the composition, while the contrast of black and white makes the tiles of the same color appear to dominate the composition.

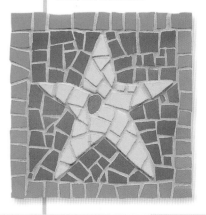

KINGFISHER

TILES

ice blue bright white

sand dark gray

mid-gray sky blue

dark blue mid-orange

bright
orange dark red

black gold-flecked
mid blue

millefiori bead

TOOLS
grease pencil
tile nippers
glue
grout

The kingfisher is a wonderful example of how nature sometimes comes up with the most dramatic and startling extremes of color to create an almost abstract beauty. This illustrational piece is all about the "zing" that color opposites, known as "complementaries," create when placed together—in this case blue and orange. Before you begin, make sure that you have a good range of tiles of both colors, because you'll want to use shades of each that are quite close together.

The strong shape of the kingfisher with its dagger-like beak is instantly recognizable. Take particular care with drawing out the wing feathers, which radiate somewhat like fingers from the front edge of the wing.

As you work on filling in the plumage on the wings, the glass tiles begin to more accurately suggest the iridescent plumage of the kingfisher. Three basic tones of blue are used here—the upper surface of the wing is differentiated by the use of the darkest blue.

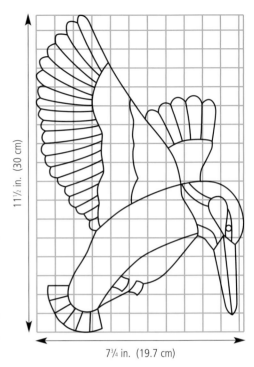

11½ in. (30 cm)

7¾ in. (19.7 cm)

▲ **Scaling and transferring the design**
To scale and transfer the design, follow the techniques described on pages 22–24. Size of design: 11½ x 7¾ in. (30 x 19.7 cm).

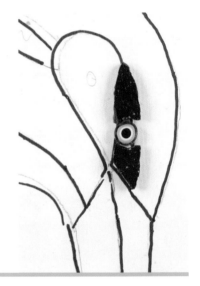

1 **Start with the eye area** The detail of the eye and the black eye-stripe are crucial in getting the picture to look right. Be prepared to make several tries to get the shards of black tile exactly cut so that there is a real sense of a beady eye looking down at its prey. Here a millefiori tile has been used to make the eye itself.

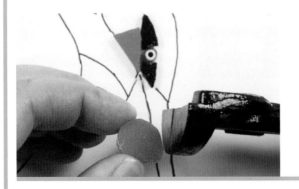

2 Next, cut and place the bright orange area around the bird's eye. Make sure that the shape is rounded.

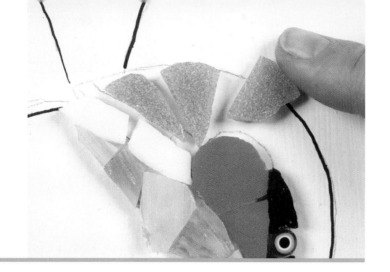

3 Fan shapes

Fan blue tiles out from this orange area, which creates the first strong color contrast.

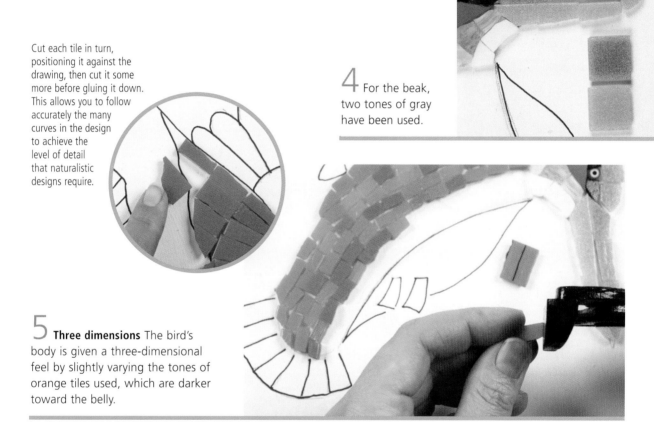

Cut each tile in turn, positioning it against the drawing, then cut it some more before gluing it down. This allows you to follow accurately the many curves in the design to achieve the level of detail that naturalistic designs require.

4 For the beak, two tones of gray have been used.

5 Three dimensions

The bird's body is given a three-dimensional feel by slightly varying the tones of orange tiles used, which are darker toward the belly.

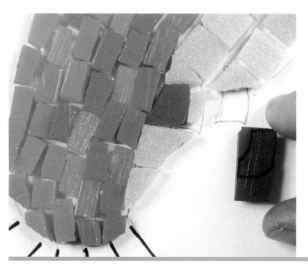

6 Details

The feet, suggested by two pieces of darker red tile, have been simplified. Don't make problems for yourself by trying to create the elaborate detail of separate toes.

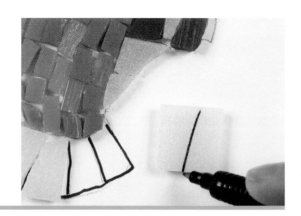

7 **Fan shape** The tail feathers are laid in a fan shape with the ends cut very straight.

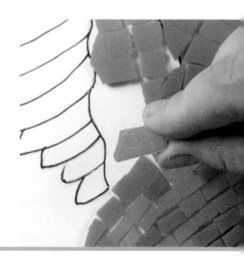

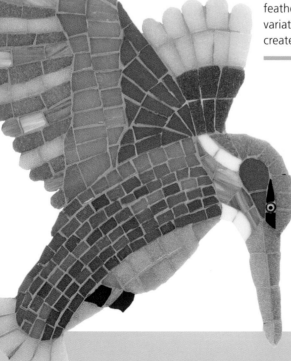

8 As with the body, two tones of orange are used. Arrange the tiles in a linear manner to give the effect of bands of feathers.

9 **Cutting rounded shapes** Cut deep, rounded U-shapes with a strong semicircular end to create the tips of the wing feathers.

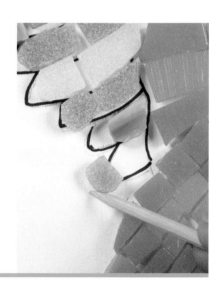

10 Three different shades of blue are used in the wing feathers. Combined with the variations in the orange, this creates variation and interest.

The vibrant orange and blue tiles shout out for attention and make the picture appear larger than it actually is.

SEE ALSO
Preparing baseboards *pages 28–29*
Placing tesserae *pages 30–31*
Gluing *pages 32–33*
Grouting *pages 34–36*
Color alternatives *pages 77–79*

MILLEFIORI HEART

MATERIALS AND TOOLS

TILES

bright orange

dark red

rose

yellow

gold-leaf tile

millefiori

TOOLS

grease pencil
tile nippers
glue
grout

Millefiori is the name given to small, intensely colored tiles that have a flower, star, or other pattern running through them—the name comes from the Italian for "thousand flowers." This design combines these beautiful tiles with some equally extravagant gold tiles to give a rich, bejeweled effect, emphasized by the small dimensions of the piece that measures just 6½ in. (16.5 cm) square. The order in which you tackle the piece is very important. Key "outlines" are tiled first to provide a container, which is then filled in with other tiles. This is a good technique to adopt when tackling many other designs too— it ensures your fills don't wander and blur the pattern.

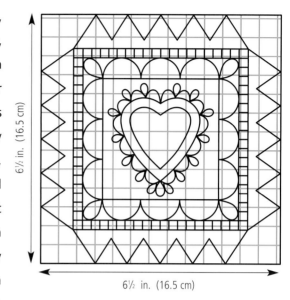

6½ in. (16.5 cm)

6½ in. (16.5 cm)

▲ **Scaling and transferring the design**
To scale and transfer the design, follow the techniques described on pages 22–24.
Size of design: 6½ x 6½ in. (16.5 x 16.5 cm).

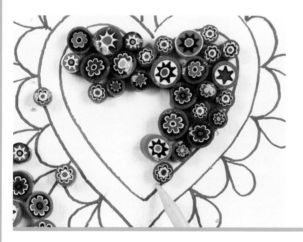

1 Start by filling in the shape of the heart with the millefiori. Use tiles of different diameters and pack them in such a way to increase the density of tiles and minimize the gaps in between that will hold the duller grout. Some of the millefiori are tiny, so tweezers are useful. Play around before gluing anything down to get the pieces as densely placed as possible.

2 Now outline the heart using the gold tiles. The tiles shown here are the real deal; made with gold leaf rather than just gold-colored. They give a warmth and richness of tone to the piece, but they are expensive. You could substitute mirror tiles to get a similar intensity.

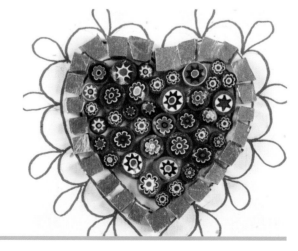

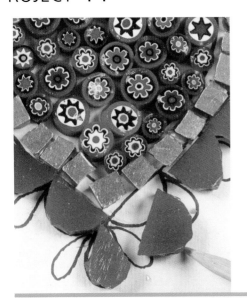

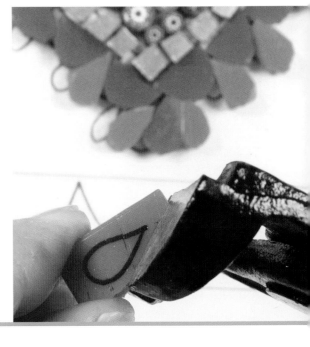

3 **Cutting half-moon shapes** Now outline the heart with the semicircular-cut, half-moon tiles—the deep red picks up the predominant color in the millefiori inside the heart, while providing a dark outline to the central motif. You'll notice in this example that all "warm" colors have been used—red, rose, and yellow—which add to the rich intensity of the piece.

4 **Cutting teardrop shapes** Place teardrop-cut tiles between the half-moons to add a final outline effect to the central motif, using a lighter, but still bright, color—here, orange.

5 Next, fill in the square that backgrounds the central heart, using a checkerboard-type fill, done here with quarters of whole glass tiles that have then been split in half again to make tiny rectangles.

You can get two quarter-moons from a single tile.

6 **Cutting quarter-moon shapes** Now return to the semicircular motif that will surround the checkerboard. Here each semicircle is made up of two symmetrical halves. These halves are made by splitting a tile diagonally, then shaping the cut edge (using nibbling techniques) to fashion it into a quarter-moon shape.

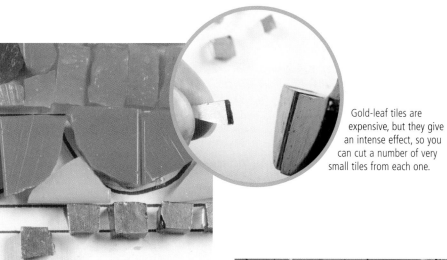

Gold-leaf tiles are expensive, but they give an intense effect, so you can cut a number of very small tiles from each one.

7 Cutting small shapes

Fill the space between the semicircles with simple triangles before outlining the square with more of the tiny gold tiles.

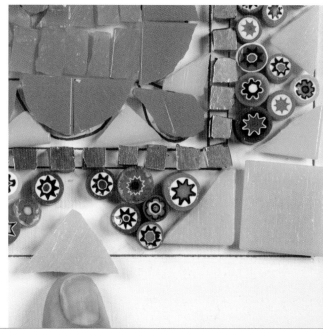

8 Complete the outside border

Place a whole tile at the four corners to establish the line of the outer border. Now go back to your millefiori tiles and select similarly sized pieces of tile to create the triangles of the outer border. Finally, use more triangular cuts of whole tiles, matching the ones placed in the corners, to fill the space between the millefiori triangles.

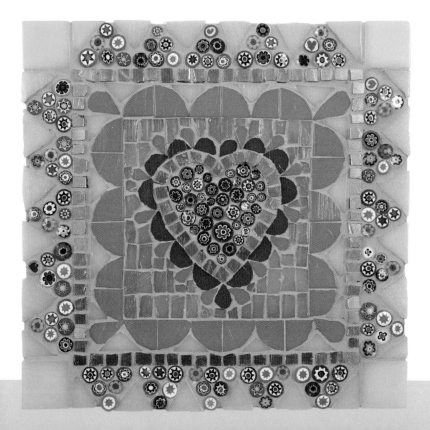

The finished piece will have an uneven surface because of the mixture of tiles used, so the final grouting is quite tricky. You may need to excavate smaller tiles that get submerged by the grout by scraping away excess grout with a wooden skewer.

SEE ALSO
Preparing baseboards *pages 28–29*
Placing tesserae *pages 30–31*
Gluing *pages 32–33*
Grouting *pages 34–36*
Color alternatives *pages 77–79*

Technique 7 OUTDOOR MOSAICS

Most of the pieces in this book, and the techniques required to complete them, are intended for indoor display. Once you are feeling confident, may want to complete a mosaic design for display outdoors—if so, then you must think carefully about both the materials and techniques you use. Essentially, you just need to bear in mind that all of the materials you incorporate into an outdoor mosaic must be capable of coping with varying temperatures, amounts of sunlight, water levels, and general weathering processes.

You could work onto wood, using specially-treated marine-ply instead of fiberboard. Strong, waterproof glues are required: try an epoxy-based resin instead of white glue. You will also need to use exterior grouts—normally these will be cement-based and mixed from a powder. However careful you are, you will probably find that moisture will eventually get behind the tiles, which will begin to crack and loosen the design over the course of time.

If you want something more permanent, it's probably better to use cement as the base for your designs. Using a wooden frame, you can make a slab with a mosaic surface that can be incorporated into paths or patio. Use vitreous glass or stone tiles, or you can work with pebbles or shells.

Mixing natural materials with tiles can work very well in mosaics that will be placed outside.

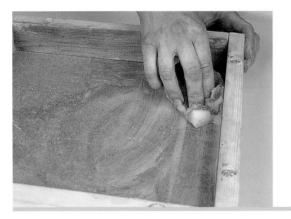

1 The frame is made using 2 x 1 in. or similar soft timber, screwed together, with a plywood base. Spread petroleum jelly over all the inside surfaces to act as a release agent at the end.

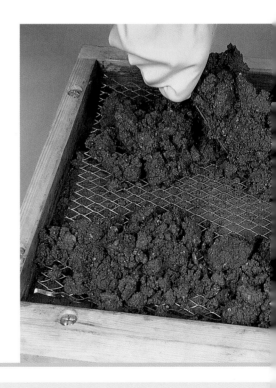

2 Fill the frame up to about one-third of its height with a 3:1 mix of sand and cement, and press in a piece of chicken wire to act as reinforcement. Then add the same amount of cement again, pressing it down and levelling with a trowel or squeegee before covering with a sheet of plastic to allow it to dry slowly for a few days. Always wear gloves when working with cement, because it is very alkaline and can be bad for the skin.

3 When dry, you can lay tiles onto the surface of the slab using a cement slurry—add cement to a small, disposable tub containing a little water and stir until you have a thick, creamy mixture. Press your tiles into the slurry, making sure you are working quickly. Only add as much slurry as you can work on in the space of 10–15 minutes. Score guidelines into the wet slurry, working from a full-size drawing as a guide.

4 With stones and pebbles you can use a board and hammer to get the surface of the mosaic reasonably level. With shells and other delicate materials, simply use the pressure of your fingers to position the pieces (see Project 12, Shell Flower Trough, on pages 88–91, for more guidance). Clear away excess cement using a damp sponge, then let dry for a couple of weeks before unscrewing and removing the frame.

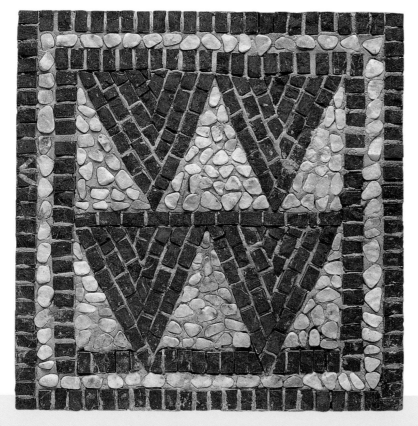

◄ Finished slabs can be laid in the same way as a paving slab—either embedded into a base of firm sand or a weak cement mix. But remember, if you have used shells or other delicate materials, these will not be suitable for floor areas that will be walked on.

SHELL FLOWER TROUGH

This piece utilizes found objects—in this case, shells, pebbles, and broken mirror glass. The techniques and way of working are somewhat different from the very precise, often painstaking way of working required with the other pieces in this book. You will need a grout suitable for outdoor use—one that is strong, waterproof, and, if you live in a cold climate, also resistant to frost. These grouts dry rapidly, so you need to work very quickly, completing areas at one time. To be able to do this, you must prepare everything carefully in advance so you can place each piece of the shell and get it right the first time.

It is best to buy a new pot so that it is clean and porous to accept the grout. You can use a pot of any shape, but a rectangular one is good to work on, because you can rest it in a horizontal position.

TIP:
Sort like-sized pebbles and shells by placing them over different coins and then grouping each size together. Reject any that have variations of color or texture.

selection of shells

mirror tiles

selection of pebbles

TOOLS
grease pencil
tile nippers
glue
grout

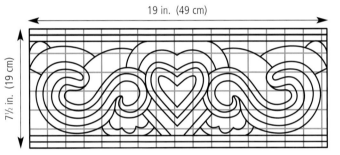

19 in. (49 cm)

7½ in. (19 cm)

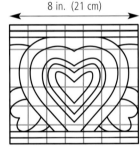

8 in. (21 cm)

1 **Sort the shells and pebbles** Grade them by size, color, and type, using trays that have compartments so that you can separate the materials. This allows you to easily select the correct elements when working under the time pressure that quick-drying grout imposes.

◀ ▲ **Scaling and transferring the design**
To scale and transfer the design, follow the techniques described on pages 22–24.

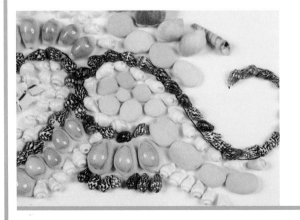

2 Draw the design full-size on a large piece of paper or cardboard, and tape it to a flat work surface where it will not be bumped—it's very easy to undo all your careful work in a second's clumsiness. Lay out the shells and stones on top of the drawing. When you are happy with the dry run, put the pot close to the drawing so you can easily move the mosaic pieces between the drawing and the grouted pot.

3 Now transfer the outline of the design onto the pot. This is only a rough guide since it will be covered with grout, but it will serve as a guide when you apply the grout in sections. A white grease pencil works best on terracotta.

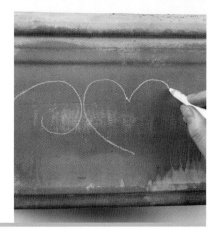

SOURCING SHELLS

You may be lucky enough to live near a beach where there are shells and pebbles, but it is not advised to collect from beaches for two reasons: first, it may be illegal to remove them, and second, you are unlikely to find the quantity and consistency that you will require to match them closely by size and color. It is far better to buy them from specialist shell shops, either in your local mall or online.

The shells used here were actually bought as part of a beaded curtain that contained thousands of shells, all very closely matched in size and color. Not only is this an economical way to buy the shells, but for some designs, you could keep them on the string to make it easier to place them in a consistent way.

4 Speed is everything. The grout needs to be laid on thickly, but in distinct sections matching areas of the design. The pebbles and shells will be pressed right into this so that the grout grips them firmly—grout will not be applied afterwards.

5 If this is your first attempt at this type of piece, it's probably worth practicing the grout application and shell application on an old piece of broken pottery, or even a brick. You need to press the objects into the grout so that they hold, but not so deep that they are submerged. But most of all, you need to work fast! Grout the sides of the pot in sections in the order that you will work on them—if you grout too large an area, it will dry before you have finished.

6 Start at the center of the design, putting on some grout with a squeegee or palette knife, matching as closely as possible just the heart motif. You can roughly clear away excess grout using an old knife.

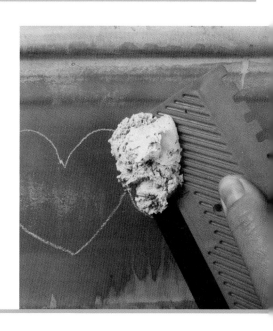

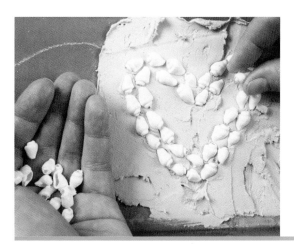

7 Working quickly, make an outline of white shells a little way in from the edge of the grout to establish the heart shape. Press in another inner row of shells to strengthen the shape.

8 Now fill in the heart with a crazy paving of mirrored glass. Press these pieces in firmly to submerge any sharp edges well below the level of the surrounding shells.

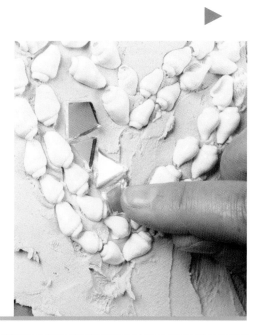

PROJECT 12

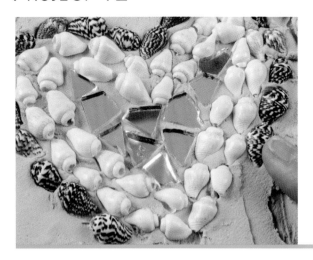

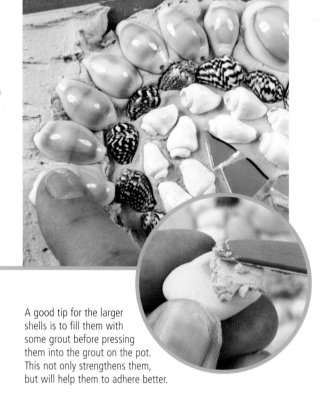

9 Finish off with an outline of darker shells, which gives the heart definition.

10 Larger shells are quickly added to the outside of the heart. With this section complete, you can now apply grout to the area to the left of the heart (but leaving the top and bottom borders for now).

A good tip for the larger shells is to fill them with some grout before pressing them into the grout on the pot. This not only strengthens them, but will help them to adhere better.

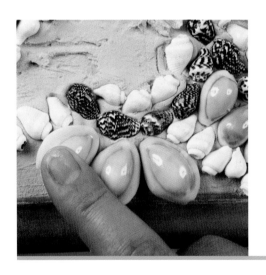

11 Again, start with the white shells to establish the outline of the "swirl."

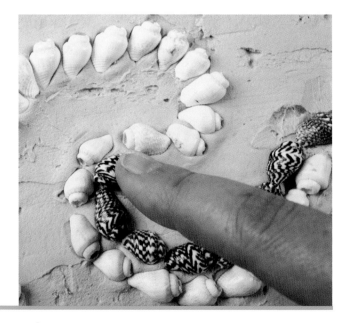

12 As with the heart, dark shells are used to snake around the outside of the motif to give emphasis.

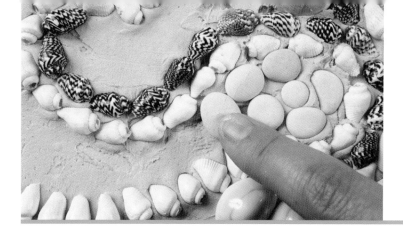

13 Then fill in with the pebbles, making sure you press them in well, since they are heavy in comparison to the shells.

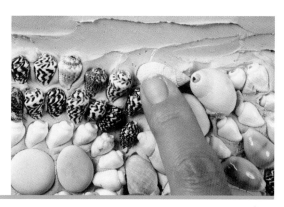

14 Fill up the design, pushing in the shells and pebbles as closely together as possible. Try to crowd each area, minimizing the amount of grout that remains visible. Repeat the design of this section, as closely as possible, as a mirror image on the right-hand side of the heart, working in exactly the same order.

15 Lastly, apply a thick border of grout along the top edge of the pot and press in the row of rectangular or square mirror pieces. Again, try to submerge the sharp edges below the grout. Repeat this border along the bottom edge.

16 Leave the first side to dry, then prop the pot up on its end and repeat the grouting and laying of the central heart motif exactly as before. Again leave to dry, then repeat on the other end. The shells are delicate, so to complete the opposite sides of the piece you will need to rest the side you have already completed on an old towel or rag to cushion the surface.

17 If you will be using the trough in the garden or as a window-box, you may not need to repeat the design on the back. Again, if you do, then pad the bottom well, and avoid leaning or placing any weight on the pot.

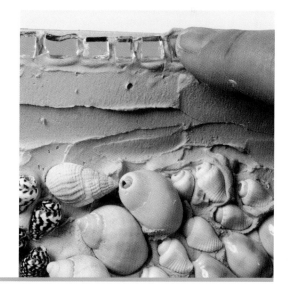

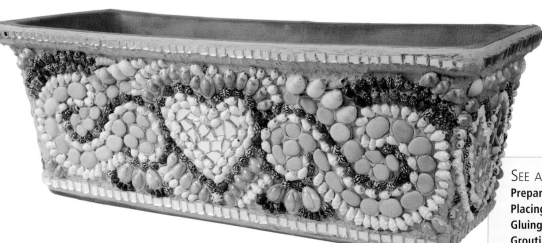

Find a home for the completed pot where it will not be exposed to harsh extremes of weather, or is at risk of being knocked or damaged.

SEE ALSO
Preparing baseboards *pages 28–29*
Placing tesserae *pages 30–31*
Gluing *pages 32–33*
Grouting *pages 34–36*
Outdoor mosaics *pages 86–87*

TECHNIQUE 8 FOUND MATERIALS

Found materials, such as crockery, shells, and pebbles, provide a way to create truly unique pieces. In fact, you can create mosaics with just about any material that lends itself to being positioned and glued to a base—including marbles, buttons, eggshells, and broken flowerpots.

Found materials require more thought and care—not only in choosing which pieces to work with but in preparing, gluing, and grouting them—but if you follow a few basic rules, you can experiment with almost anything that gives a result you find pleasing.

TIP:
STRIKE CAREFULLY
When breaking crockery, avoid striking too close to the areas of pattern you wish to use—break lines are more unpredictable with a hammer than with your tile nippers!

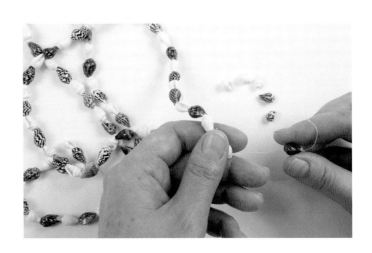

SHELLS AND PEBBLES

Shells and pebbles provide natural colors and textures with which you can produce interesting effects. However, they are seldom regular in size and color, so before starting to incorporate them into a piece, sort and grade them into groups.

◄ When working with pebbles, try to select ones that are thin and flat so that there is a greater surface area to glue down and support their weight.

▶ If the material on which you are working is very porous, such as this terracotta flowerpot, seal it first with diluted craft glue. This will prevent the surface from absorbing all the moisture from the grout, causing it to dry too quickly and crack.

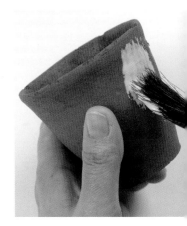

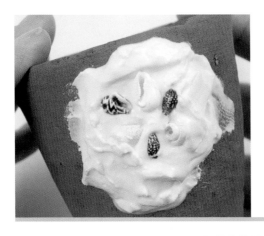

◄ Shells and pebbles need to be embedded in the grout and left to dry. It is best to practice first, to get the hang of the technique and avoid a mess. You need just enough grout to hold the pieces in place. If you use too much, you will risk submerging them, as illustrated here.

CROCKERY

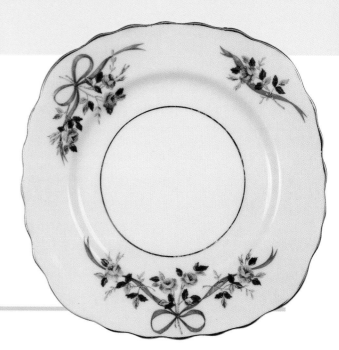

1 Old crockery can bring originality and character to a mosaic design. Look for old plates and saucers with interesting details that use unusual colors and motifs. With most crockery, the curvature of the piece will be a problem, so try to select plates on which the interesting pieces of the pattern you want to work with are on flat areas. When you have no alternative, you may have to resort to breaking curved sections into very small pieces so that you can create a reasonably flat surface to create your mosaic pattern.

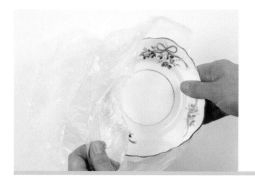

2 The best way of breaking a plate or saucer is to place it inside a plastic bag in order to contain the fragments.

A plate broken in a restrained way, rather than shattered into hundreds of fragments, can be incorporated whole into a larger design.

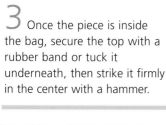

3 Once the piece is inside the bag, secure the top with a rubber band or tuck it underneath, then strike it firmly in the center with a hammer.

When working with china from different sources—perhaps an old wall tile mixed with fragments of a delicate tea-set—you will find that you also have to accommodate pieces of varying thickness. Look at Project 13, Dancing Ladies, on pages 98–101, to see how you can deal with this unevenness by building up the area behind some of the pieces to make the end result more level.

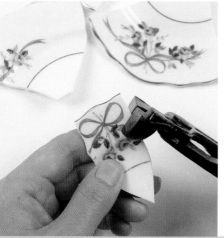

4 Use nippers to work on the fragments and to take off the excess tile from around the motif or section of pattern you want to use. "Nibble" at the shape carefully to achieve the shape you want. Be aware that old china can be difficult to work with and can break unpredictably. It can also sometimes cut you unexpectedly, so take care.

TECHNIQUE 9 PAINTING TILES

Using ceramic paints when you are working with ceramic tiles allows you to add an extra dimension to your work and completely individualize a piece. You will mainly want to use ceramic paints in two ways—to copy patterns from elsewhere (or to create your own original patterns), or to add illustrational details that are too fine to be created by cutting tiles. Some mosaic purists might argue that the use of these types of materials isn't real mosaics—in fact, in all of the examples described, the technique is being used to create tiles with which to mosaic, rather than to create a ceramic painting on top of tiles that are already in place.

TIPS:

USING PAINTED TILES
While painted tiles are fairly durable, it is not advisable to use them on objects or surfaces that will be scrubbed or cleaned frequently, such as worktops or crockery that will be used on a daily basis.

REMEMBER
Ceramic paints are intended for use only on ceramic tiles, not on glass or vitreous tiles.

CERAMIC PAINTS

Ceramic paints are a relatively new invention that allows anybody to create bright, durable colors on ceramic materials. Previously, the only way to do this was to use professional glazes that required the ceramic material to be heated to hundreds of degrees centigrade in a kiln (typically, between 1472 and 2192°F (800 and 1200°C)). Ceramic paints, however, can be "fired" in an ordinary domestic oven. They are easy to use, non-toxic and are generally water-soluble. They are also relatively inexpensive and easily obtained through craft shops.

SIMPLE PATTERNED TILES

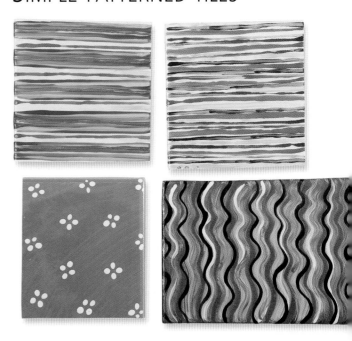

▲ For your first use of these materials and to practice the techniques involved, it is best to start with simple patterns. Take some white household tiles, making sure they are clean of dust or grease, and draw some simple lines, alternating two or three colors. Try also using colored tiles and creating patterns with clusters of dabs or spots. After "baking," the large tiles can be cut with a tile cutter or nippers into regular-sized small squares or rectangles to use as your mosaic material.

► Smaller, detailed designs give you more "intense" tiles with less waste. The larger motifs probably work better cut to make larger sized tiles.

Here, hand-drawn designs have been combined with a crackle infill of tiles to create an interesting frame for a mirror.

► These black-and-white designs have a 1950s "modern" feel. The tiles on the left are black with white ceramic paint applied; those on the right are white with black paint applied. As you can see, the paints are very opaque if applied and fired properly. It is almost impossible to draw perfect "ruled" lines with a brush, so don't try—exaggerate the unevenness and make this a feature of your designs.

PAINTING SHAPED TILES

▼ Another approach is to cut your shapes first and then paint your design to fit the shape—here, a series of flowers have been painted onto some similar, button-sized circles of tile.

►

◄ You can also cut asymmetric shapes and make your design follow these, such as in this paisley pattern. Furthermore, you can combine cut pieces of different shapes and sizes painted.

PAINTING FEATURES

▶ The second use of ceramic paints is to provide fine detail, such as the features of faces. Cut out the shapes of the face first, then paint them. You can combine a number of separate tile pieces to make a head or face. Keep everything very stylized. Here the faces are doll-like, using simple lines, blobs, and basic colors. Take inspiration from cartoons, comics, and illustrations.

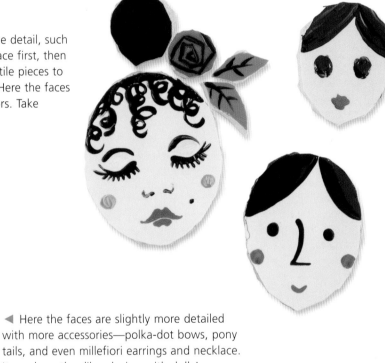

◄ Here the faces are slightly more detailed with more accessories—polka-dot bows, pony tails, and even millefiori earrings and necklace. It can be rather like playing with dolls!

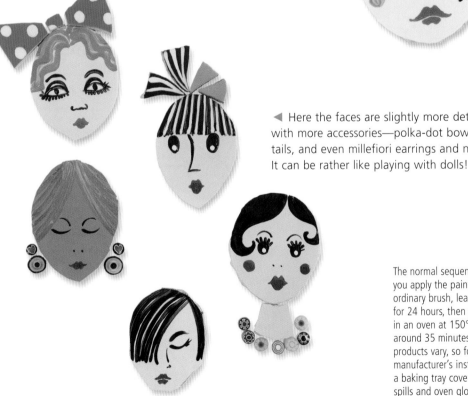

The normal sequence is that you apply the paint with an ordinary brush, leave it to dry for 24 hours, then put the pieces in an oven at 150°C (300°F) for around 35 minutes. However, products vary, so follow the manufacturer's instructions closely. Use a baking tray covered with foil to prevent spills and oven gloves to protect your hands.

PAINTING STYLIZED FLOWERS

1 In time, you can develop more complex arrangements of painted pieces. These different shapes fit together to build into a rose design. Use colored tiles, paint your pieces all over with a background color first, let them dry, and then add the contrasting outline.

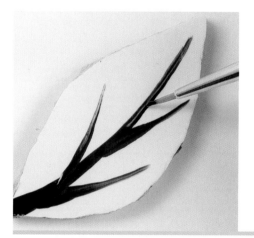

2 A good quality paint brush will allow you to make sweeping, smooth shapes.

3 Complement the flower head with leaf shapes. Here, you could paint the leaf veins in white on black tiles or the reverse—i.e., black paint on white tiles.

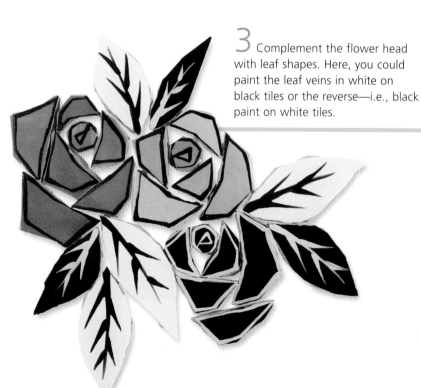

4 Here, a multitude of the same flower motifs have been combined to create a large, exuberant piece.

DANCING LADIES

Mosaic art does not have to be rigidly tied to small, uniform tiles. Found objects of many types can be utilized to give interesting and novel effects. These dancing ladies have been created using pieces of smashed crockery and ordinary household tiles, then finished off with details such as diamanté beads, and facial details painted onto the tile with oven-cured ceramic inks.

The drawing can be merely a rough guide as to where the larger pieces of crockery and tile will be placed. The fragments themselves—and the patterns on them—will suggest how they should be cut. The basic design makes a delightful picture, and could be extended into a larger frieze of ever more weird and wonderful dancers.

MATERIALS AND TOOLS

TILES

sky blue
brown
ice blue
lilac
yellow
dark blue
cream
black
orange
white
red
khaki

ceramic
paints

diamanté
pieces

china
pieces

TOOLS

grease pencil
tile nippers
glue
grout
hammer
oven
paintbrush

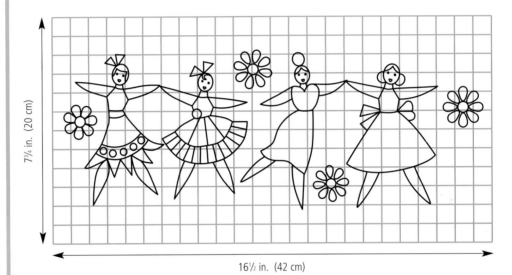

7¾ in. (20 cm)

16½ in. (42 cm)

▲ **Scaling and transferring the design**
To scale and transfer the design, follow the techniques described on pages 22–24. Size of design: 7¾ x 16½ in. (20 x 42 cm).

If you want to paint the ladies' faces, you will need to do it before you glue them down. Start by cutting ovals of the right size for the head of each figure. Using ceramic paints (see page 94) and a fine brush, carefully dab two blobs of dark ink for the eyes; then, with a clean brush and using a simple stroke, paint the lips. Finally, the tiles should be baked in an oven at the correct temperature to harden them.

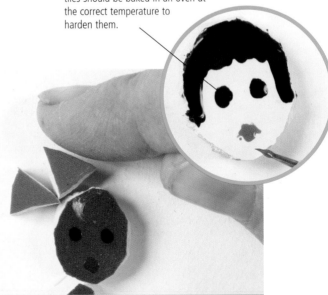

1 Start by laying down the "baked" faces (see detail) and add hair and adornments such as ribbons and bows.

SOURCING CHINA

First, find your china pieces—from garage or rummage sales, local thrift shops, or use broken household dishes. "Louder" designs from older plates have been utilized here to great effect—hunt around to build up a variety of patterns and motifs. Try to imagine how details or parts of a larger design could be utilized to suggest a flowing dress, or the curves of a bodice.

Smashing china isn't as easy as you would think—it takes some force. Always wear goggles and gloves, and take sensible safety precautions. Second-hand plates tend to be more brittle and to break in an unpredictable way. There are two ways to approach this task. Place old plates and other crockery inside a couple of plastic bags, lay them on the ground, and then hit them forcefully with a hammer or other blunt instrument. Alternatively, still wearing goggles, use your tile nippers to break away the parts you don't require, leaving the particular shape or pieces of pattern that you do want to use in the design.

2 Now move on to the bodice—be creative in the selection of patterns and fragments that you use. Look for elements that work as fabric patterns, or suggest the shape of the figure, or that have a strong symmetry. The limbs of the dancers are cut from single pieces of large household tiles. These are quite soft and easy to work with using tile nippers, but draw the shape you want to achieve with a grease pencil first.

3 Here is an example of using the pattern of a plate to create a wonderful skirt—the fragment suggests the flow and shape of a Fifties-style outfit.

4 To make it easier, you can stick the china fragments onto a piece of paper cut to the shape of the skirt, then move and position this as a single piece before gluing it down.

PROJECT 13

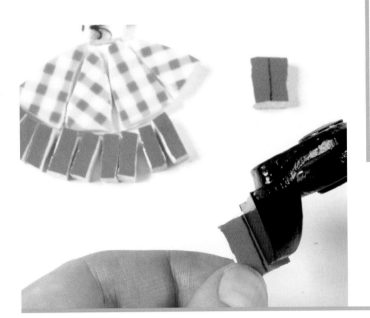

WORKING WITH VARYING THICKNESSES
The china fragments are likely to be of different thicknesses, or even curved if you are using large, single pieces from a plate or saucer. If so, raise the thinner pieces by putting extra grout/adhesive underneath them, or even pieces of cork or cardboard with lots of white glue sandwiched in between to make sure everything sticks securely.

5 Cut small shapes from plain tiles to add variety and interest to your design as borders, fringes, tassels, pom-poms, etc.

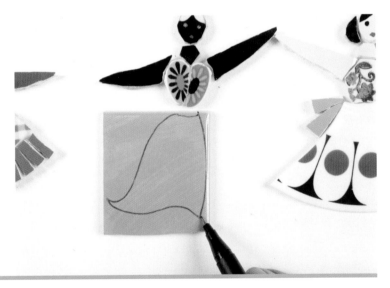

6 Here, a whole piece of ceramic tile has been used to make the skirt of one dancer. Draw your shape with a felt-tip pen, then take great care "nibbling" the tile—be patient, you can do it!

7 To break up the background, use simple daisy motifs made from two simple cuts—a circle and several teardrops.

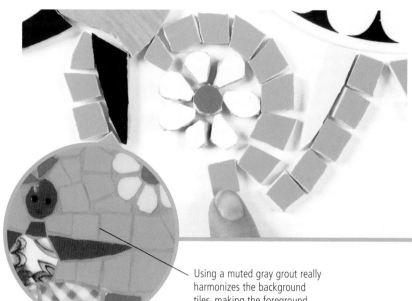

Using a muted gray grout really harmonizes the background tiles, making the foreground details really stand out, especially on the ladies' skirts.

8 The background fill has been kept very plain and neutral, with small squares tapering around the figures to add to their sense of movement. A gray grout further unifies the background; its similar tone holding everything together.

9 After the grout has set, have fun adding glass beads, diamanté, buttons, or anything else that takes your fancy. It's your picture, so enjoy creating your own design.

Clever positioning means that the ladies appear to be holding hands and dancing in a circle or line, creating a very jolly scene. There is a good sense of energy and exuberance in this simple mosaic.

SEE ALSO
Preparing baseboards *pages 28–29*
Placing tesserae *pages 30–31*
Gluing *pages 32–33*
Grouting *pages 34–36*
Found materials *pages 92–93*
Painting tiles *pages 94–97*

TECHNIQUE 10 LIGHT SOURCES

When working on the projects in this book—or later, when you go on to develop your own mosaic designs and pictures—it is useful to have a basic understanding of how light works.

A single directional light source, such as from a window or light bulb, will always create the most light on the surface of an object closest to the light, with the darkest part of the shadow behind the opposite side of the object. In between, there will be a range of midtones that vary according to the amount of light falling on the surface.

▲ If the object or light source is moved in relation to the other, the highlight and shadows will also move, as can be seen in the picture above. As the light is moved, the shadow underneath the egg and the highlight on the top surface of the egg move in opposite directions—the shadow away from the light source, the highlight towards it.

OVERHEAD LIGHT SOURCE

In this simple mosaic of a ball, the different areas of light and shadow have been exaggerated. The light source is directly above the ball, so the highlight is on the top of the ball. The "footprint" of the shadow is very small—just as it is when the sun is overhead. Resist the temptation to use black tiles to create a "proper" shadow: the end result often looks flat and dead (here, the left side of the shadow has been tiled in black tiles, the right in brown, so that you can compare the finished result).

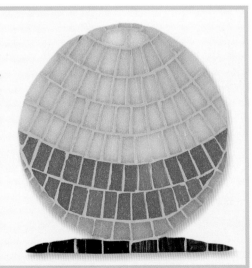

TIPS:

TONES

Before creating a piece with a strong light source, make sure you have a range of tiles of different tones of each color to work as the "highlight," "midtone," and "shadow."

DRAW GUIDES

Draw strong construction lines on your baseboard tin another color to show the direction of light and to map the shadows of objects.

OBLIQUE LIGHT SOURCE

The drawing shows how you can construct the shadows in a design by deciding where the source of light is, then drawing parallel lines from that source to show where the edges of the shadow will be.

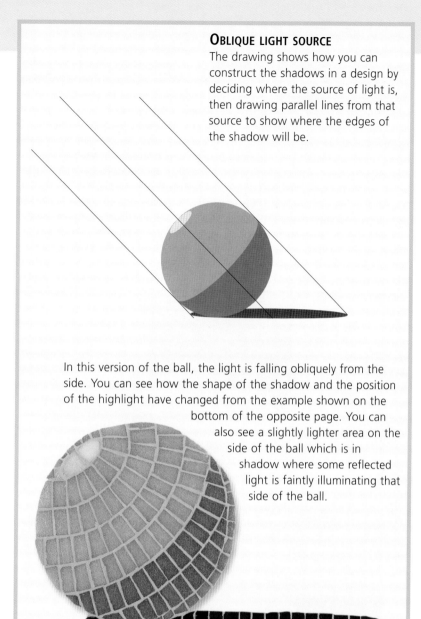

In this version of the ball, the light is falling obliquely from the side. You can see how the shape of the shadow and the position of the highlight have changed from the example shown on the bottom of the opposite page. You can also see a slightly lighter area on the side of the ball which is in shadow where some reflected light is faintly illuminating that side of the ball.

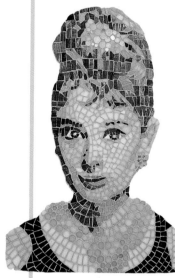

▲ In this striking portrait of Audrey Hepburn, which uses the techniques employed in Project 9, light and shadow have been used to good effect.

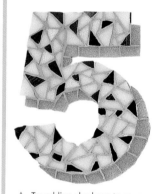

▲ Try adding shadows to your mosaics, using the principles outlined on this page.

◀ The shadow of an object, most noticeably a brightly colored one, will contain a hint of its complementary color of the object (see the section on color for an explanation of complementaries). Project 15, Red Pepper, on pages 106–108, uses dark green tiles in the shadow. Play around with very dark tiles in a number of hues to make the shadows in your mosaic pictures more interesting and less flat.

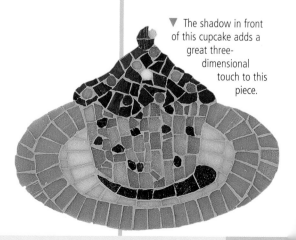

▼ The shadow in front of this cupcake adds a great three-dimensional touch to this piece.

CIRCUS SEAL

TILES

red

dark brown

lemon

orange

black

ice blue

rose

mint green

mirror tiles

googly eye

TOOLS
grease pencil
tile nippers
glue
grout

This piece takes the simplest of shapes—the circle—and illustrates four alternative ways of using mosaic fills to create entirely different effects. The seal is little more than an outline, but the strong shape, the "oiliness" of the shiny brown tiles, and the placement of a googly eye combine to give him character and humor.

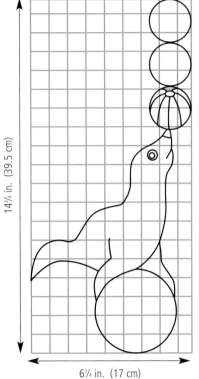

14¾ in. (39.5 cm)

6¾ in. (17 cm)

▲ **Scaling and transferring the design**
To scale and transfer the design, follow the techniques described on pages 22–24. Size of design: 14¾ x 6¾ in. (39.5 x 17 cm).

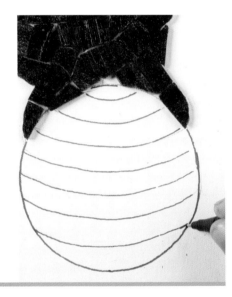

1 Fill in the shape of the seal using very dark but not completely black tiles. Make sure you keep the sense of balance, taking particular care of the tail and flippers gripping the ball. Now move on to the largest ball on which the seal balances. Draw curved bands that suggest the latitudinal lines on a globe.

2 Fill in the mirror ball Use quarter cuts of small mirror tiles—these could be cut these from larger pieces of mirror glass, but it is not a good idea; glass tends to shatter unpredictably and, while the tiles are a bit more expensive, you will have far less waste. Either way, the edges are often razor-sharp, so be careful at every stage, including grouting and cleaning the mosaic.

3 Draw out the beach ball The first ball the seal is balancing is based on a traditional beach ball. Cut a small elliptical tile (like a "flat" circle) to suggest the top of the ball.

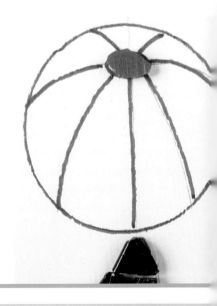

Even when you are quite experienced at cutting tiles, it is still worth drawing guidelines to ensure accurate cuts, particularly when dovetailing small fragments together.

4 Add radiating bands in alternating colors, with each tile fragment fattening toward its base. Again, the shape of the ball is suggested by a strong "equator" line running around its middle.

The finished piece has a precarious feel—as if the seal and all the balls could tumble at any moment!

5 The next ball up is given a strong concentric, geometric fill, but in a uniform color. Cut as near a perfect circle as you can and place this exactly in the middle, then work outward with circular bands of tiles of similar sizes, with the edges cut at an angle so that they dovetail smoothly together.

6 The last ball is given a random "crackle" mosaic, with the strength of the color helping to make this choice of fill work.

The mirror ball and the beach ball are the most naturalistic treatments because the lines of tile most accurately describe a sphere when seen in perspective, yet the top two balls work just as strongly as "elements" in the design. Other alternative fills suitable for circles would be a spiral extending from the center of the shape, or a completely flat checkerboard fill of square tile pieces cut to the curve of the circle around the edges.

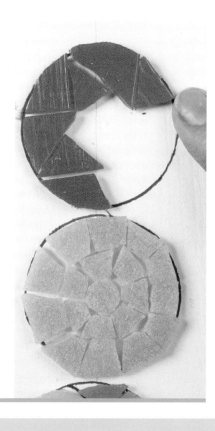

SEE ALSO
Preparing baseboards *pages 28–29*
Placing tesserae *pages 30–31*
Gluing *pages 32–33*
Grouting *pages 34–36*
Light sources *pages 102–103*

RED PEPPER

TILES

light red

white

rose

bottle green

light green

burgundy

mint green

dark red

ice blue

TOOLS
grease pencil
tile nippers
glue
grout

This is a classic "still life" in which, like a painter, you learn to create a sense of light and shadow from solid raw materials. The bold coloring of the subject helps keep things simple—the piece uses just a few tones to create a luscious red pepper that looks good enough to eat.

If you like drawing, you can create your own study of a pepper, other vegetable, or piece of fruit. It helps if you have a strong directional light source, either from a window or tablelamp, to create the strong highlights and shadows that make this work.

If you're not confident about your drawing skills, then work from a photograph—either one you have taken yourself, or perhaps one you find in a cookbook. Trace around the outline of the pepper, then try to divide the shape into light, dark, and midtones. If you have a digital camera, you can take a picture and manipulate it with photo software to simplify it into a few tones (see Project 9, Statue of Liberty, on pages 74–76).

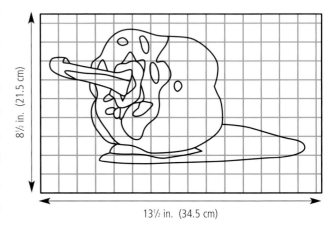

8½ in. (21.5 cm)

13½ in. (34.5 cm)

▲ **Scaling and transferring the design**
To scale and transfer the design, follow the techniques described on pages 22–24.
Size of design: 8½ x 13½ in. (21.5 x 34.5 cm).

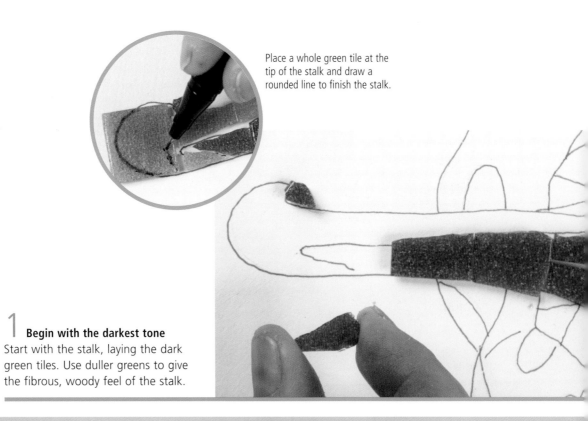

Place a whole green tile at the tip of the stalk and draw a rounded line to finish the stalk.

1 **Begin with the darkest tone**
Start with the stalk, laying the dark green tiles. Use duller greens to give the fibrous, woody feel of the stalk.

2 Around the base of the stalk, use some darker red tiles to give emphasis and strength.

3 Next, move on to the pink highlights to establish the left edge. This is the lightest of the three reds you need in your color palette.

4 **Use white tiles for highlights** Now place the rounded white tiles that give the highlights. Fill in the mid-red around the base of the stalk. Work around the stalk, following the shape of the pepper. Try to get the final grout to "contour" the bulges and curves of the pepper, rather than use a flat fill of each tone. Continue into the dark red area, still using the tiles to suggest the three-dimensional forms.

5 **Fill in the pepper's shadow** Avoid using pure black tiles to create the shadow of the pepper—it looks harsh and unnatural. Immediately under the stalk, use dark brown to suggest the color of the pepper being reflected in the shadow.

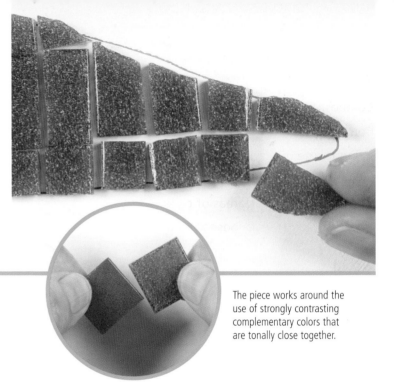

6 For the rest of the shadow, use a very dark green. This is borrowed from a technique used by the French Impressionists who painted shadows with a hint of the color opposite to the object (in this case, green as the opposite of the red of the pepper). Extend the shadow to balance the stalk and to suggest low, end-of-the-day light, rather than harsh overhead light.

The piece works around the use of strongly contrasting complementary colors that are tonally close together.

7 **Background** Finish off with a simple checkerboard background in a third strong color. Try to keep all the background tiles whole. You'll need to master concave cuts so that the background fits the shape of the pepper.

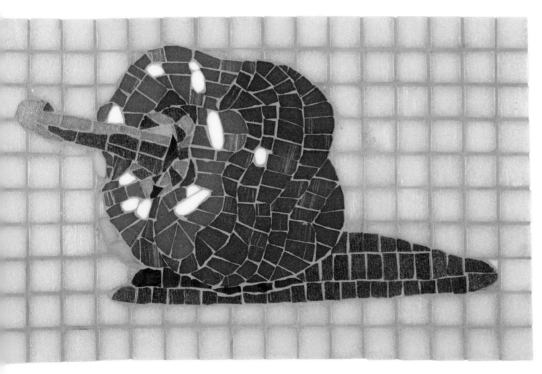

Mosaics can make wonderful functional objects: this design could be adapted for a chopping board. Both tiles and grout are resilient to this type of use (although grout can stain or discolor), but remember that they are not dishwasher-proof and should be handled with reasonable care.

SEE ALSO
Preparing baseboards *pages 28–29*
Placing tesserae *pages 30–31*
Gluing *pages 32–33*
Grouting *pages 34–36*
Light sources *pages 102–103*

COMPOSITION

Composition is the way the elements of a picture or design are placed and arranged. Composition can be used to achieve balance and harmony through the positioning and sizing of the different elements, as well as the use of color. The way a picture is composed will also provide a path for the eye to follow. This path may be created by using lines or boundaries between areas of different tones and colors that guide the eye, or it may work more subtly through positioning elements—such as spots of color—that act as stepping stones to guide you through the picture.

In the end, there are no hard-and-fast rules—sometimes a design can work by going against all the guidelines of what makes a good composition, drawing the view in by creating a sense of imbalance and discord.

One way of composing a design is to draw the elements on separate pieces of paper and move them around, experimenting with different combinations.

Here, the separate elements of the Jungle Menagerie (Project 16, pages 112–119) have been drawn, then cut out. By moving the pieces around on the baseboard, you can see alternative compositions that might work.

ARRANGING YOUR COMPOSITION

In some instances, when making your own designs—a still life, for example—you can actually manipulate the objects themselves, trying them in different positions in relation to each other to see what the best composition is. You can then make a drawing (or take a digital photograph) to use as the basis of your design.

EXPLORING DESIGN IDEAS

◄ Some compositions definitely won't work—here all the elements have been positioned too far to the left, making it look unbalanced.

◄ Here, the positioning of the elements makes the elephant appear to float in the air.

TECHNIQUE 11

▶ Centering all the elements, however, can make the design too crowded and weaken the "framing" of the picture.

▶ Here, the various elements seem vertically disconnected, and isolated. What is needed is a more cohesive feel to the piece.

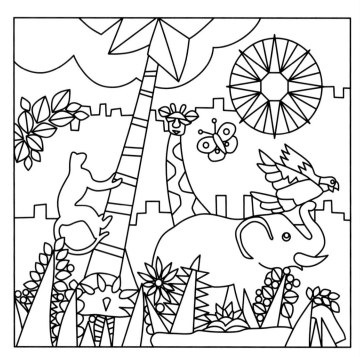

Once you have a composition you are happy with, tape the pieces to your work surface and trace the drawing, then transfer it to your baseboard in the usual way.

THE KEY ELEMENTS OF COMPOSITION

Composition is as important a consideration for mosaicists as it is for all other artists. There are entire books devoted to this subject, but here are a few of the key considerations that can help make a strong composition.

▲ **Path and focus** The positioning of elements that provide a path to lead the viewer through an image can be strong or subtle. Sometimes an image will work to a rigid grid onto which key elements are placed exactly. For example, a design might be divided into thirds, with key elements positioned on some of the intersections of the imaginary dividers between each third.

Less obviously, a path may be constructed through the image, not necessarily using strong lines but possibly through subtle variations in tone, or by adding small highlights of a strong color that act as stepping stones to lead the eye. The construction of a path that manipulates the viewer's gaze in this way is perhaps the most controlling compositional technique.

PROPORTION

Commonly a picture or design will be described as "portrait" or "landscape." A portrait image is one where the height is greater than the width; a landscape image is one where the width is greater than the height. Your subject matter will generally suggest which is the right fit—trying to shoehorn a design into a format that is too narrow or too short will create problems from the outset. Sometimes, however, you can successfully crop part of a design to fit into an unusual shape.

▲ Landscape

◀ Portrait

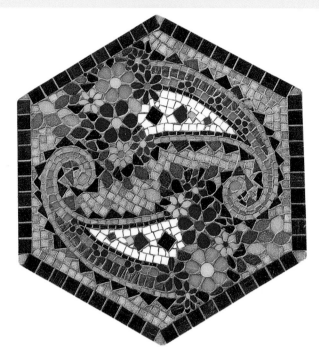

▲ **Balance** The way the different elements of design work together—or in opposition to each other—gives a sense of order and balance. A strongly symmetrical design may have almost perfect balance, but may not sustain our interest. Often the juxtaposition of elements of varying shapes, sizes, and colors creates more interest by establishing a tension between the elements. The end result holds our attention because the design seems more dynamic. The great skill is to manipulate the elements so that they work together as a whole, rather than fighting each other.

◀ ▼ **Positive and negative** As important as the subject of a picture or design is the space around it—often the two elements are referred to as the positive and negative areas of the picture. A clear division and balance between the two elements gives a stronger effect than when the elements blur, or where one dominates the other.

JUNGLE MENAGERIE

dark gray | black

white | pale gray

sky blue | aquamarine

dark blue | olive green

turquoise | ice blue

pale magenta | pale lilac

brown | coffee

bright orange | sea blue

This is the "finale" piece for the book, bringing together many of the techniques we have covered in the preceding techniques and projects, and adding a few new ones. It is a large picture—almost a mural. You could scale the drawing larger, then embellish each animal and plant with further detail and variety, but bear in mind that the larger you go, the heavier it will be, and you will need to use strong fastenings to mount it securely on a wall.

The piece uses household ceramic tiles that give a strong chunky feel and have the advantage that you can work with large pieces and shape them quickly, making it quicker to fill what is a big area.

It's also a piece in which composition is key—the animals are separate elements that you can reposition, repeat, or even substitute with other animals/elements that you find elsewhere. Because it has a flat, almost cartoonlike feel, don't worry too much about the size of each piece in relation to the next one. What is important is to get an overall balance to the piece, so that each area is neither too overcrowded nor too empty of color and interest.

Once you have scaled up your drawing, the approach to follow is to take one element at a time.

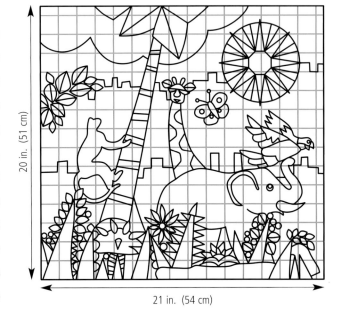

20 in. (51 cm)

21 in. (54 cm)

▲ **Scaling and transferring the design**
To scale and transfer the design, follow the techniques described on pages 22–24.
Size of design: 20 x 21 in. (51 x 54 cm).

1 Start with the foliage, using large shards of green tiles of different tones. Position these first as the stems, and then create the foliage around them.

2 The pebbles at the bottom of the picture provide a variation in texture. Equally, you could use glass beads, shells, or other found objects.

CONTINUED
OVERLEAF ▶

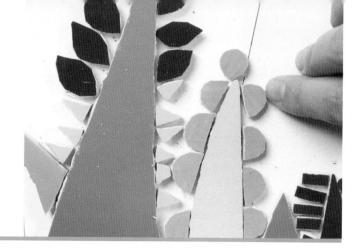

3 Different cuts and shapes are used for the leaves: half-moons, small triangles, simple rectangles, and whole leaf shapes.

4 This flower shape (as is much of the picture) is inspired by the work of the French painter Henri Rousseau. The cuts used are simple triangles, semicircles, diamonds, and U-shapes (look back at the rooster project on pages 50–52 to remind yourself of these cuts). Keep the placement of the pieces symmetrical.

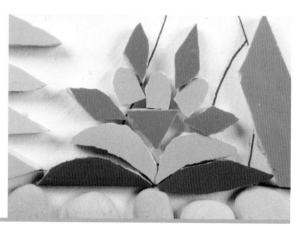

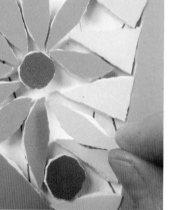

5 These flowers are very simple. Cut a central circle, then position a selection of slim, leaf-shaped fragments for the petals. Keep them large and exuberant, cutting across the bottom petals so they appear to go behind the leaves in the foreground.

6 These "leaf pairs" are made from a single leaf shape, split in half. Small circles are placed in between to suggest fruit berries.

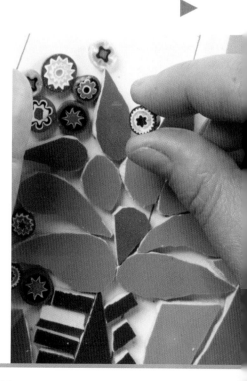

7 Carefully chosen millefiori have been used to add an exotic dimension to the picture.

Project 16

TILES CONTINUED

dark green

emerald green

yellow

red

pebbles

millefiori

TOOLS
grease pencil
tile cutter
tile nippers
glue
grout

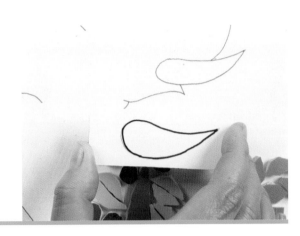

8 Next, place the tusk of the elephant, which you must carefully shape from a single piece of white tile. Persist in cutting this as one element because it strengthens the design—you may lose a few attempts to breakage along the way.

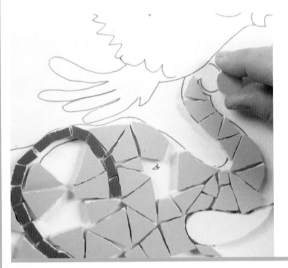

9 Create the outline for the ear, using carefully cut rectangular shapes in a darker shade of gray, tapering them at the ends. Now use a crackle fill, which gives the aged, creased feel of the animal's hide. If you are going to use a stick-on googly eye, then fill the whole outline of the animal: the eye will be glued on after the whole piece is finished and grouted. If you want to use a millefiori tile, or a small fragment of tile cut into a circle, you will need to cut the tiles in front of the ear so as to leave a small hole to accommodate the eye.

10 Again, use large pieces of green tiles of different tones to create the leaf fronds of the palm tree. A tile cutter will give you a strong, clean diagonal line.

11 Use large chunks of brown or maroon tile for the trunk. Concentrate on getting the outside line absolutely straight. The dark bands get thicker toward the bottom of the trunk. At the end of the trunk, cut into the bottom of the tile to create a curve that fits around the flowers and foliage of the foreground.

12 The monkey is a silhouette made up of small square-cut pieces of tile. Again, it's important to get the flow of the back and limbs, creating lines of grout rather than just using a random fill. The face is shaped from a single rounded piece—no more detail is needed.

13 Start the sun with a centrally placed octagon of bright orange (see detail).

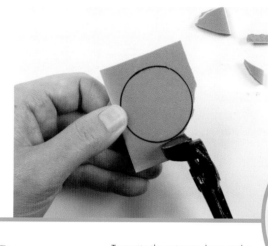

To create the octagon shape at the center of the sun, cut a circle, then draw in the arms of a cross and the diagonals in between. Rule across between where each line intersects the circle, and apply your tile cutters along these lines.

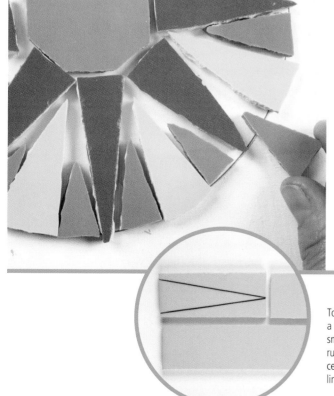

14 For the rays of the sun, cut red tiles into strips, then cut these diagonally to create "shards" (see detail). Finally, square off the bottoms so that each shard is a very thin isosceles triangle. Place them around the center, then fill in between with triangles of yellow, then the remaining gaps with smaller orange pieces.

To cut the triangles for the sun and foliage, use a tile cutter to create strips, then cut these into smaller rectangles of the correct length. Use a ruler to connect the corners at one end to the center point of the other, then cut along these lines with tile nippers.

PROJECT 16

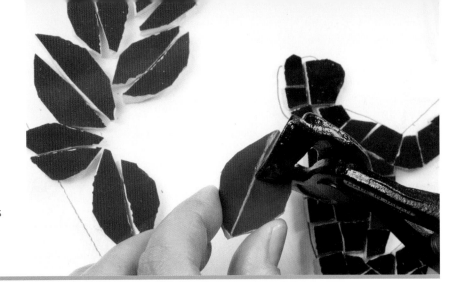

15 Use more leaf pairs to add the large branches of foliage that protrude into the picture.

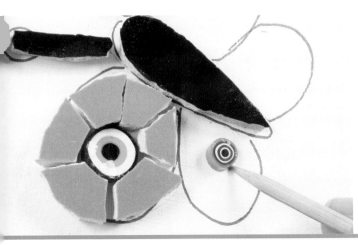

16 The butterfly is made up of two circles with the concentric fill that was used in the circus seal project on pages 104–105. Remember to angle the tile pieces so that they dovetail together. Very small circles of black tile have been used to provide the "eyes" at the end of the antennae.

You can give added emphasis to the eye of the parrot by making it protrude slightly above the level of the surrounding tiles. Pad out the back of the tile with extra grout or other materials, or, if you are using millefiori, by placing two thinner ones on top of each other.

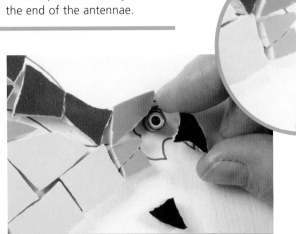

17 Now move on to the parrot. (This is best attempted when you have the position of the elephant established in the "background.") Again, it is important to get the placement of the eye right, as well as the cutting of the hooked, nutcracker beak.

18 The giraffe can be tiled any time after you have the body of the elephant in place. Try to get the curve of the neck to rise out of the curve of the elephant's back. The neck should curve gently backwards to add to the animal's aloofness. Place the dark tiles first along the outside line of the neck, then fill the spaces in between with cream-colored tiles. Practice cutting the eyes and mouth until you produce the same shape in consistent sizes. These tiles are the crucial details to create the heavy-lidded, haughty expression of the animal.

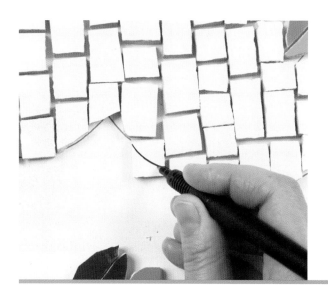

19 The clouds in the background are created from rectangles of the same width, but of different heights. The outline of the cloud behind the tree needs to be cut with care to achieve a smooth and continuous outline.

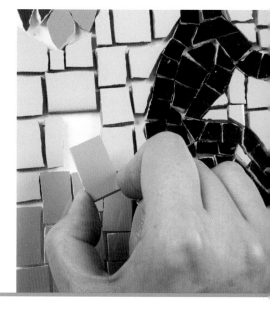

20 The same fill as the clouds continues into the remainder of the background. This fill gives a regularity and calmness, but without the harshness or monotony of a checkerboard fill. The main background has been banded into different tones of blue to give a sense of recession. You could experiment with mixing the tiles more, but you must be careful not to make the background a distraction. Try to keep the overall effect cool and controlled.

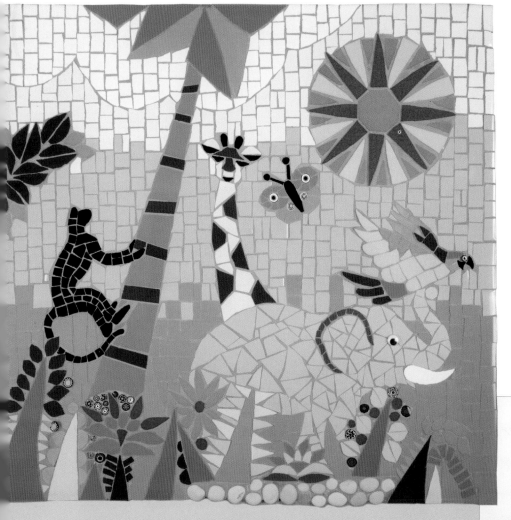

The finished piece will delight children and will both fascinate and comfort them in a bedroom or nursery. But adults can enjoy the design too!

SEE ALSO
Preparing baseboards *pages 28–29*
Placing tesserae *pages 30–31*
Gluing *pages 32–33*
Grouting *pages 34–36*
Composition *pages 109–111*

HANGING YOUR WORK

Traditionally, mosaics have been seen as an architectural feature of the building in which they are housed. From ancient times, mosaic designs have been integrated permanently into the fabric of walls or floors where they can stay for hundreds—in some cases thousands—of years.

The decorative mosaics in this book are meant to be less permanent and are designed to be moved and rehung. Nearly all of the projects have been created so that they can be completed as a panel that can be taken down and moved if necessary. This section looks at ways of hanging and mounting the finished pieces.

USING A KEYHOLE HANGER

For small pieces, a metal "keyhole" hanger is ideal. This has a slot designed to fit over a screw head placed in a wall. The slot is wider at the bottom so that it can be slipped over the screw, but narrower at the top so that when it is in position, the hanger cannot slip off the screw if the piece is knocked or disturbed. The hanger is held in place by two small screws of suitable size.

The hanger can be attached to the back of the mosaic with suitable screws so that the keyhole protrudes along the top edge of the baseboard. Make sure that you measure and place the keyhole hanger centrally, or the piece will be lopsided.

Alternatively, you can use a large drill bit to make a hole in the back of the baseboard over which you place the keyhole hanger. This has the advantage that the hanger cannot be seen when the piece is hung.

HIDING A KEYHOLE HANGER

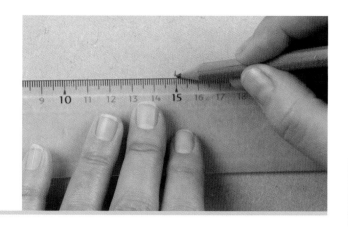

1 Start by measuring and marking a point that is horizontally central on the back of the board and about 1½ in. (30 mm) below the top edge.

2 Place your keyhole hanger and trace around it, marking the position of the slot, as well as the position of the screws that will hold the hanger.

TIPS:

If you have completed any of the projects in this book, you will have realized just how heavy the combination of baseboard, tiles, and grout can be—even for a small mosaic. It is therefore important to mount the finished pieces safely and securely.

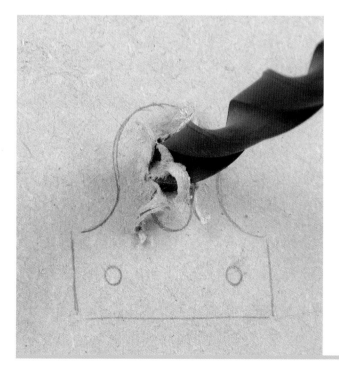

3 Now select a large drill bit that is larger in diameter than the head of the screw onto which the hanger will be hung—generally, a drill bit around ⅜ in. (10 mm) in diameter should be fine. Then drill out the wood around the outline of the keyhole. Be careful to drill into the baseboard only enough to fit over the head of the screw. If you drill too deeply, you may go right through and damage the mosaic. You may need to drill three or four holes to create the sort of slot shown above.

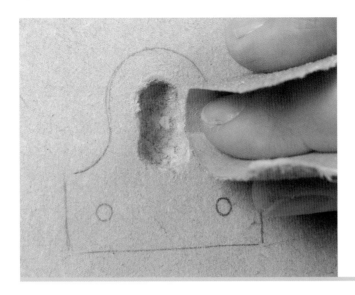

4 Clean up the slot you made, using sandpaper. Check that the head of the screw you intend to use can move freely within it.

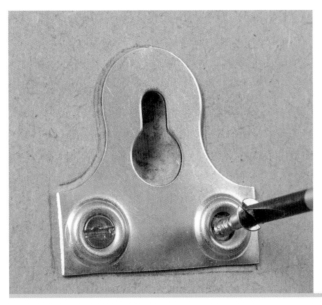

5 Now screw the keyhole hanger to the baseboard.

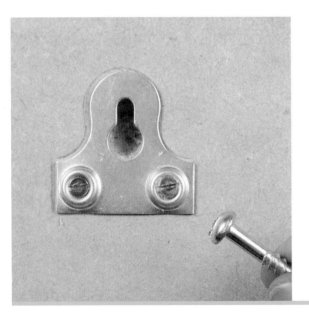

6 Using round-headed screws for hanging the piece gives the most secure fit. Screw these into the wall and leave a length of screw showing so that you can hang the keyhole hanger over it. Always use screws of sufficient length—at least 1¾ in. (30 mm) long—and combine these with the correct type and size of wall plugs so that they embed firmly into the wall. Take care when drilling into walls—wear eye protection and be careful that you don't drill through electric cables or pipes.

For larger pieces, and particularly for those that are to be hung up high or above a bed, it is advisable to use a number of keyhole hangers to hold the piece in place. For a very large piece use four—attach two at the top protruding above the back of the baseboard, and two at the bottom protruding below. You will probably need another person to help you hold the piece in place while you mark where the holes are to be drilled (use a spirit-level to ensure that the picture is level).

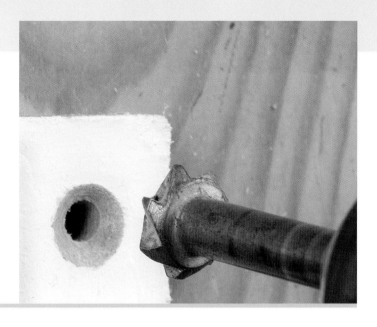

PERMANENT MOUNTINGS

1 Another way to mount a large piece more permanently, or when you don't want the mountings to be visible, is to drill holes in the corners of the baseboard before you begin tiling. Leave the holes exposed, but tile and grout the rest of the piece.

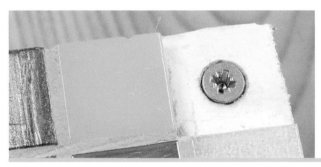

2 The piece is ready to be mounted on the wall using flat-headed screws (you should countersink the holes in the baseboard so that they are level with the surface of the board).

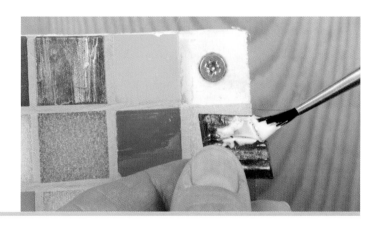

3 When in place, you can complete the mosaic with the pieces that cover the screws.

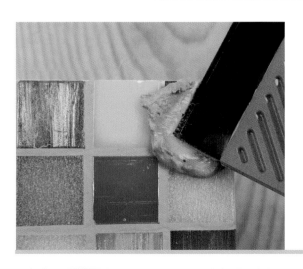

4 Carefully grout, then clean these small areas so that the mounting is completely hidden.

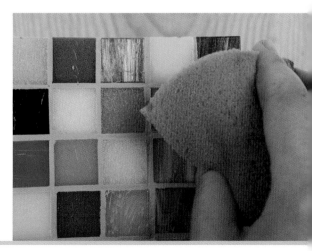

PROFESSIONAL TIPS

MAKE THE BASEBOARD YOUR INSTRUCTION MANUAL

In addition to the basic design, you can use the baseboard to set down all the information you need to ensure you lay the tiles correctly. Remember the board is going to be covered by the tiles, so you can scribble on notes and reminders of which tiles to use and the correct sequence to follow.

Go over difficult details with a dark pencil or felt tip to ensure that you can still follow the design even through a layer of glue.

If the design uses checkerboard fills of alternate colors or tones, shade the dark areas so that you can follow the correct sequence of tiles.

When following a complicated color scheme, shade in the different colors with colored pens, or use a system of numbers to represent the different tiles.

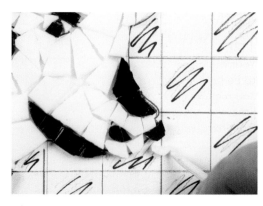

▲ Shading in the black squares makes laying tiles much easier. Remember that any marks you make on the baseboard won't be visible on the grouted, finished piece!

TILES AND COLOR BATCHES

Before embarking on any project make sure that you have sufficient tiles of the colors you need to complete the piece. Remember that even factory-made tiles can vary slightly in their hue and tone and nothing looks worse than a background or other flat area of color changing inexplicably and for no reason. If you cannot find tiles that are exactly the same, then, before you begin, randomly mix tiles that are as close as possible to avoid any "banding" in the finished piece.

BE ON THE LOOKOUT FOR INSPIRATION

Always carry a small notebook with you so that you can jot down drawings or notes about things that suggest ideas for a mosaic. The natural world—landscape, flowers, and water—provides a rich source of ideas about shapes, colors, and patterns. So too does the man-made environment— buildings, shop windows, signs, fabrics, and printed materials vie for our attention. As you develop a visual awareness, you will frequently encounter patterns and designs that will inspire you. But be sure to make some sort of record—however short—or the idea will be lost for good.

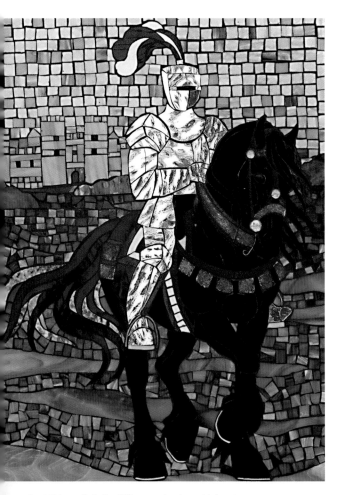

▲ Mixing slightly different shades of blue is a great way to represent the sky, or water—in nature, the sky is rarely a solid, consistent color. In this fabulous mosaic, the tiles for the background elements have been subtly varied, which also allows the foreground elements to stand out in all their unified glory.

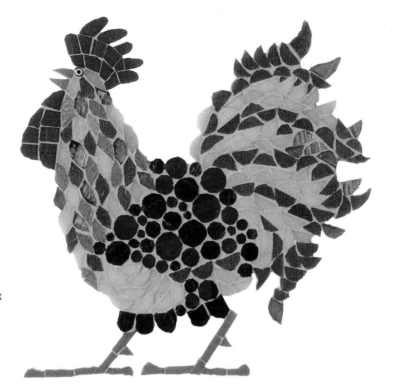

THINK OUTSIDE THE BOX

Your designs do not have to be limited to squares and rectangles. An electric jigsaw—available cheaply from hardware stores—allows you to experiment with all sorts of shapes—from simple hearts and oblongs through to complex outlines of animals or other motifs.

◀ *A jigsaw was used to cut out the intricate outline of the baseboard for the Rooster project on pages 50–52.*

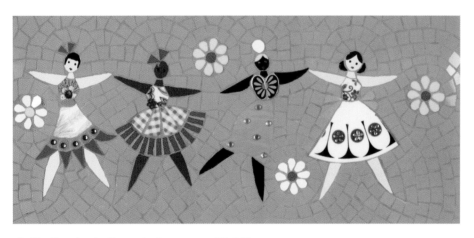

▲ *The Dancing Ladies project, on pages 98–101, uses a mixture of materials, and offers plenty of scope for you to experiment with an even wider variety of materials. You can incorporate anything that can be glued down and grouted!*

BE CONFIDENT AND EXPERIMENT

There are several examples in this book of mixing various sorts of materials and tiles. Be bold and try out different materials—whether shells, crockery, pebbles, or beads—as long as you understand the different requirements for fastening them to your baseboard, the end result can often be exciting. Treat every project as part of the learning curve—sometimes things work, sometimes they don't, but you will always learn something that will help improve your next piece!

LOOK AND LEARN

Sometimes ideas just do not flow or a piece of work disappoints. When you get stuck or dispirited spend a few minutes looking back at some of the "giants" of mosaic—the pieces created by often-anonymous Greek and Roman artisans. Such work can remind you of the basics of the medium—simple but clear designs, accurate but flowing placement of the tiles, and the use of a limited but strong color palette.

▶ *This 4th-century AD mosaic beautifully illustrates the story of Odysseus and the Sirens, from Homer's* Odyssey.

RESOURCES

USA

Artful Crafter, Inc.
741 Lawson Avenue
Havertown, PA 19083
Tel: 1 877 321 2080
www.artfulcrafter.com

D&L Stained Glass
4939 North Broadway
Denver, CO 80304
Tel: 1 800 525 0940
www.dlstainedglass.com

Delphi Stained Glass
3380 East Jolly Road
Lansing, MI 48910
Tel: 1 800 248 2048
www.delphiglass.com

Dick Blick Art Materials
P.O. Box 1267
Galesburg, IL 61402-1267
Tel: 1 800 723 2787
www.dickblick.com

Ed Hoy's International
27625 Diehl Road
Warrenville, IL 60555
Tel: 1 800 323 5668
www.edhoy.com

Hakatai Enterprises
695 Mistletoe Road, Suite C
Ashland, OR 97520
Tel: 1 541 552 0855
www.hakatai.com

Happycraftn's Mosaic Supplies
28244 Essex Avenue
Tomah, WI 54660
Tel: 1 608 372 3816
www.happycraftnsmosaicsupplies.com

KP Tiles Mosaic Tile Supplies
1832 Star Batt
Rochester Hills, MI 48309
Tel: 1 248 853 0418
www.kptiles.com

Mosaic Basics
1856 Chrysler Drive, NE
Atlanta, GA 30345
Tel: 1 404 248 9098
www.mosaicbasics.com

Mosaic Mercantile
P.O. Box 78206
San Francisco, CA 94107
Tel: 1 877 9 MOSAIC
www.mosaicmercantile.com

Mosaic Tile Supplies, LLC
555 Black Branch Road
Coldspring, TX 77331
Tel: 1 936 767 8502
www.mosaictilesupplies.com

MosaicTile.com
432 Maple Street, Suite 10
Ramona, CA 92065
Tel: 1 888 2 MOSAIC
www.mosaictile.com

Norberry Tile
Seattle Design Center
5701 Sixth Ave. South, Suite 221
Seattle, WA 98108
Tel: 1 206 343 9916
www.norberrytile.com

Pompei Mosaic Tile
11301 Olympic Blvd., Suite 512
West Los Angeles, CA 90064
Tel: 1 310 312 9893
www.pompei-mosaic.com

Tile Specialties
P.O. Box 807
High Springs, FL 32655
Tel: 1 386 454 3700
www.tilespecialties.com

Wits End Mosaic
5020 South Ash Ave., Suite 108
Tempe, AZ 85282
Tel: 1 888 4 WITS END
www.mosaic-witsend.com

CANADA

Interstyle Ceramic & Glass Ltd
3625 Brighton Avenue
Burnaby, Vancouver, V5A 3H5
Tel: 0604 421 7229
www.interstyle.ca

UK

Edgar Udney & Co Ltd
The Mosaic Centre
314 Balham High Road
London SW17 7AA
Tel: 020 8767 8181

Focus Ceramics
Unit 4 Hamm Moor Lane
Weybridge Trading Estate
Weybridge
Surrey KT15 2SD
Tel: 01932 854881
www.focusceramics.com

Mosaic Workshop
Unit B
443–449 Holloway Road
London N7 6LJ
Tel: 020 7272 2446
www.mosaicworkshop.com

Reed Harris Ltd
Riverside House
27 Carnwath Road
London SW6 6JE
Tel.: 020 7736 7511
www.reed-harris.co.uk

Tower Ceramics
91 Parkway
Camden Town
London NW1 9PP
Tel: 020 7485 7192
www.towerceramics.co.uk

AUSTRALIA

Flat Earth TileWorks
4 Forth Street
Kempsey, NSW 2440
Tel: 02 6562 8327
www.midcoast.com.au/~vanz/

Metric Tile
38–42 Westall Road
Springvale, VIC 3171
Tel: 03 9547 7633
www.infotile.com.au/metrictile

Mosaria
311 Colburn Ave
Victoria Point, QLD 4165
Tel: 07 3207 6380
www.mosaria.com

GLOSSARY

Andamenti
These are the lines along which mosaic tiles are laid, the lines of coursing of the mosaic.

Ceramic tiles
Ceramic tiles are made from thin layers of fired clay. They are a popular mosaic material on account of the wide range of colors available and the fact that many types of tile can be easily cut and shaped with standard tools, such as tile cutters and tile nippers.

Fixing
To fix a mosaic is to set it in its final location.

Grout
The cementitious matrix which fills the gaps between tiles. Grouting refers to the process of applying grout to a mosaic.

Laying
To lay is to put the individual tiles of a mosaic in place.

Millefiore
Literally "thousand flowers" in Italian, this term refers to small tesserae created by the fusion of many glass rods arranged so that the cross section creates a flower pattern. These rods are then sliced thinly and encased in glass.

Opus
This is the Latin word for work. The plural is "opera."

Opus musivum
This is an effect rather like ripples on a pond, with repeated rows of tesserae spreading out to fill a background to the edges of the mosaic area.

Opus paladanium
A random-like, crazy-paving effect of placement of irregular mosaic tesserae.

Opus regulatum
As the name suggests, this is a very regular pattern of tesserae, like bricks in a wall, or squares on a chessboard.

Opus sectile
This is a technique where, instead of being made up of lots of individual tesserae, shapes in a picture are made from larger, specially cut, pieces (perhaps of tile or stone).

Opus verniculatum
A single row, or several rows, of tesserae following the outline of a feature (such as a figure or other subject) in a mosaic. The effect is a little like a halo, highlighting the subject and providing contrast against a background with tesserae laid in a different style. "Vermiculatum" means "wormlike" and is so called because it curves around the contours of the design.

Smalti
Enamelled glass of the kind used in Byzantine mosaics.

Squeegee
A tool for spreading grout. The spreader has a rubber blade on one edge which helps force the grout into all the spaces.

Tesserae
These are the components of a mosaic, which may include cut and uncut tiles, pebbles, and found objects.

Tile cutter
A tool specifically designed for cutting ceramic tiles, although it can sometimes cut other materials such as glass. The cutting process has two stages. A thin blade (typically a cutting wheel) is drawn across the surface, making a small straight score mark in the glaze. Then pressure is applied evenly on either side of this line to snap the tile along the line. Handheld and bench-mounted versions are available.

Tile nippers
A handheld tool for breaking and snipping mosaic materials such as vitreous glass tiles, ceramic tiles or crockery.

Vitreous glass
Square mosaic tiles made in molds from glass paste. They have a smooth top and a rough, textured back.

INDEX

CREDITS

Quarto would like to thank the following artists for kindly submitting work for inclusion in this book:

Key: a = above, b = below, l = left, r = right

110r Laura Aiken www.simplemosaics.com
111ar Marcelo José de Melo www.marcelodemelo.com
111br Mary-Kei Macfarlane www.mkmosaics.co.uk
122bl Judy Wood www.glasswoodstudio.com

Quarto would also like to acknowledge the following photographers:

123b Ruggero Vanni/CORBIS
Statue of Liberty. Page 74bl Bob Krist/CORBIS

All other photographs are the copyright of Quarto Publishing plc. While every effort has been made to credit contributors, Quarto would like to apologize should there have been any omissions or errors—and would be pleased to make the appropriate correction for future editions of the book.

AUTHOR'S ACKNOWLEDGMENTS

To S.P.O.D.E., with love.

Thanks to Paul, my sis Rachel for her fab hands, Martin for his help with the photoshoots, and the people at Quarto for all their encouragement and support.

Teresa Mills, June 2006.

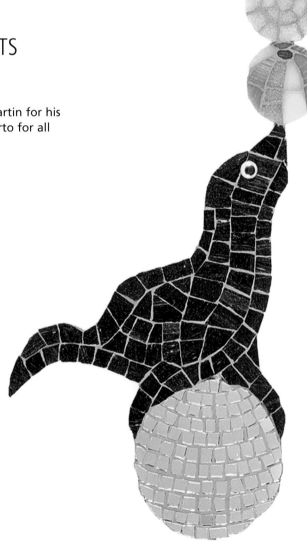